The Natural Way to Paint

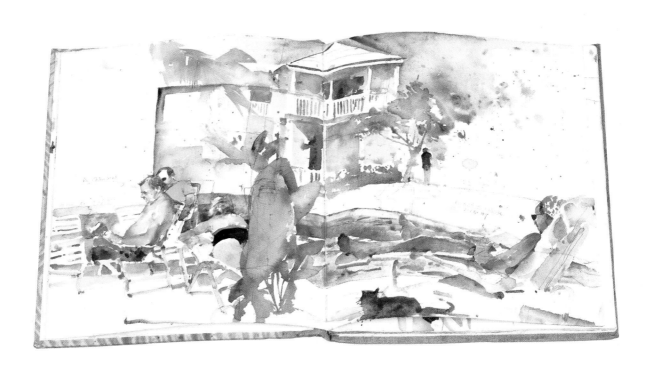

The Natural Way to Paint

Charles Reid

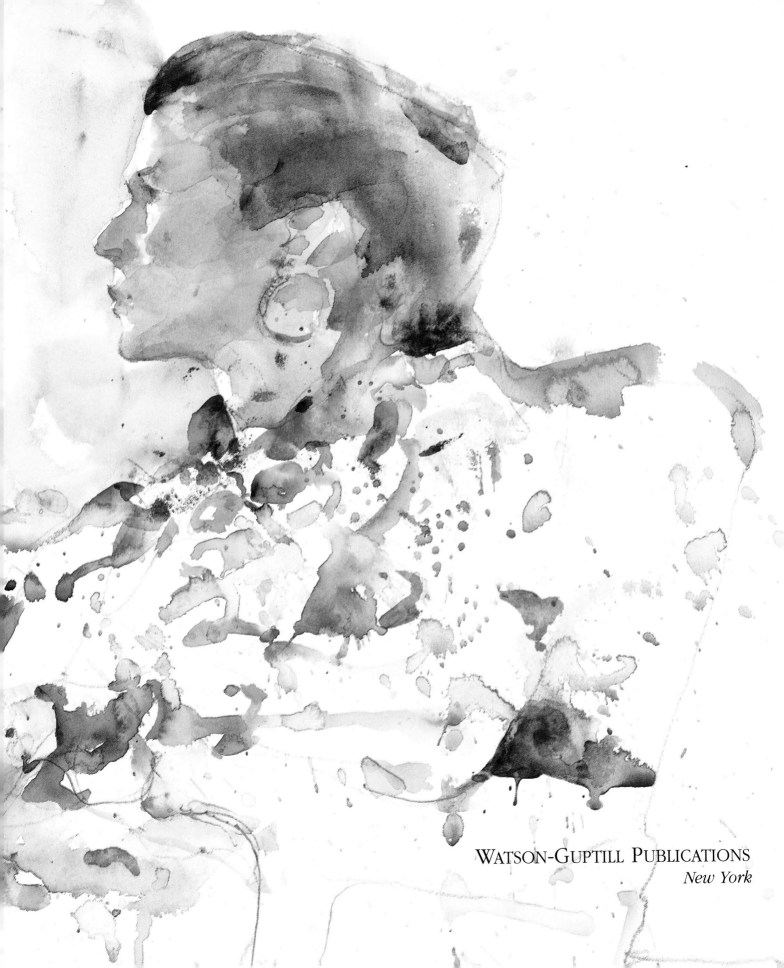

WATSON-GUPTILL PUBLICATIONS
New York

For Judith

My thanks to my wonderful editor, Marian Appellof,
and thanks to Jay Anning, who did the excellent design.

Copyright © 1994 Charles Reid
First published in 1994 in New York by Watson-Guptill Publications,
a division of BPI Communications Inc., 1515 Broadway, New York,
N.Y. 10036

**The Library of Congress has catalogued the hardcover edition of this
book as follows:**

Reid, Charles, 1937-
The natural way to paint/ Charles Reid.
 p. cm.
Includes index.
ISBN 0-8230-3158-6
 1. Human figure in art. 2. Watercolor painting-Technique. I. Title.
ND2190.R46 1994
751.42'242-dc20 94-28590
 CIP

ISBN (paperback) 0-8230-3173-X

Manufactured in Malaysia

1 2 3 4 5 6 7 8 9/08 07 06 05 04 03 02 01 00

First paperback printing 2000

Art on page 1:
DUVAL ST.
90-lb. cold-pressed sketchbook paper, 13½ x 21¾" (34 x 55 cm)

Art on pages 2–3:
ELIOT'S DAUGHTER
*Winsor & Newton 140-lb. cold-pressed paper, 18 x 24"
(45.7 x 61.0 cm)*

Art on pages 8–9:
SKETCH CLASS MODELS
Old Dutch 140-lb. cold-pressed paper, 16 x 20" (40.6 x 50.8 cm)

Art on pages 34–35:
WAITING FOR THE RISE
*Strathmore hot-pressed paper, 18 x 24" (45.7 x 61.0 cm),
courtesy Sports Afield*

Art on pages 54–55:
HARRY IN MENDOCINO
Fabriano 140-lb. cold-pressed paper, 18 x 24" (45.7 x 61.0 cm)

Art on pages 84–85:
MELISSA
Old Dutch 140-lb. cold-pressed paper, 16 x 20" (40.6 x 50.8 cm)

Art on pages 96–97:
JUDITH IN PHOENIX
90-lb. cold-pressed sketchbook paper, 10⅞ x 13½" (27.5 x 34 cm)

Art on pages 124–125:
RAY PAINTING ON PALM ISLAND
90-lb. cold-pressed sketchbook paper, 12 x 18" (30.5 x 45.7 cm)

Contents

INTRODUCTION 7

PART ONE
Contour and Gesture Drawing

Getting Started with Contour Drawing 10
Using the Dot-to-Dot Approach 12
Putting Contour Drawing into Practice 14
Developing Bulk and a Third Dimension 16
Contouring with Pen and Wash 18
Placing Features Correctly 19
Gesture Drawing, Front View 22
Gesture Drawing, Back View 28
Gesture Drawing, Kneeling Figure 31

PART TWO
Painting Techniques and Color

Materials 36
Brushwork 40
Stroking On Paint 43
Mixing Flesh Color on the Paper 44
Dark Complexions 46
Gesture Painting 50
Composing with Spots of Color 52

PART THREE
From Silhouette to Three-Dimensional Form

Painting Simple Silhouette Figures 56
Adding Monochrome Shadows 58
Making Color and Value Changes 60
Describing Form with Shadow Shapes 62
Integrating Cast Shadows 68
Making Forms Project 70
Working with Lights and Darks 76
Painting the Light 78

PART FOUR
Facial Features

Understanding Facial Structure 86
Gauging Feature Placement Accurately 88
Eyes 90
Noses 92
Mouths 94

PART FIVE
Figure Painting Demonstrations

Capturing the Model's Pose 98
Painting a Black Model 104
Painting a Nude 106
Painting a Clothed Figure 114
Integrating Figure and Background 120

PART SIX
Composing and Designing Figure Paintings

Composing with Sketch Class Figures 126
Flattening the Picture Plane 128
Choosing the Essentials 136
Adding Figures to Landscapes 138

INDEX 143

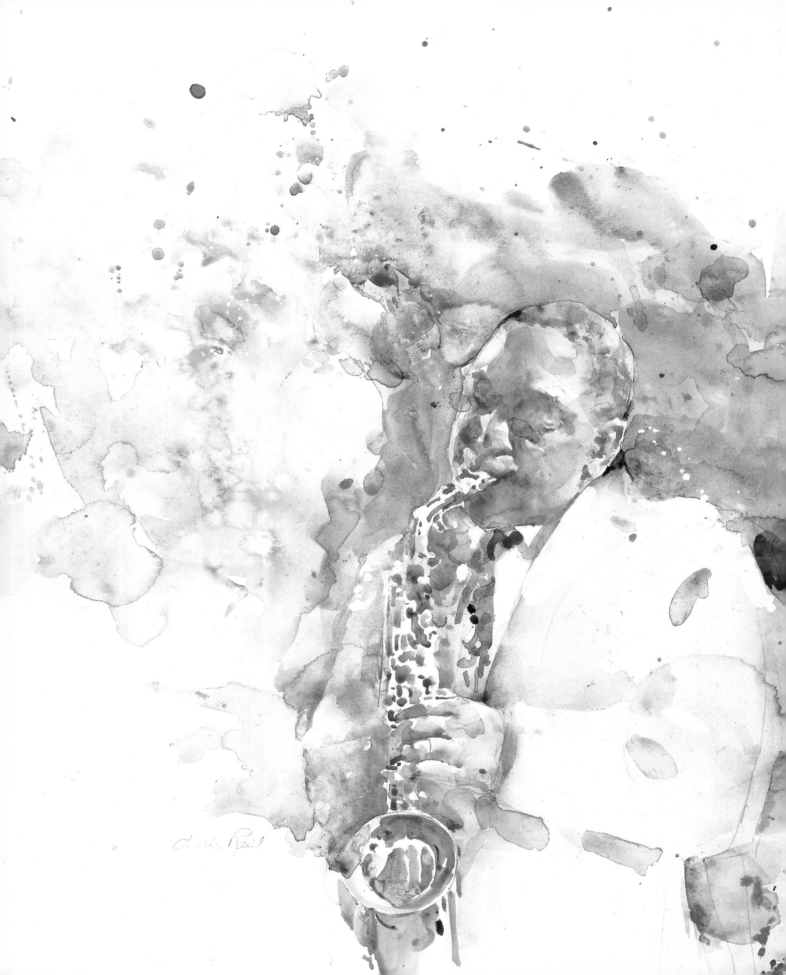

INTRODUCTION

I was trained as an oil painter. I was working as a correspondence art instructor at Famous Artists School when my supervisor needed someone to do the watercolor figure lessons. He called me in and gave me a demonstration in watercolor. I remember that the subject was a tugboat. He showed me how to soften an edge in the smokestack and how to create the illusion of smoke with the wet-in-wet technique. The supervisor's name was Frank Jones, and happily he had a wonderful hand with watercolor but no interest in the mystique often associated with it. He thought a week of my doing the tugboat lesson would be sufficient training in the medium before I had to start on figures. Frank didn't do figures, so it was left to me to come up with an approach. At the time, there wasn't much watercolor figure work to look at that was understandable. (John Singer Sargent was and is beyond comprehension.) Fortunately, I ran across some Lord & Taylor fashion illustrations by Dorothy Hood. They were magnificent in their simplicity and directness. She used just two values in the skin—light and shadow—and she didn't bother much with softening edges. This became my approach. I started to go to a weekly sketch class, and the work I produced there became the basis for my first book, *Figure Painting in Watercolor*.

This little history leads me to the premise of this book: Watercolor figure painting isn't a big deal.

Regardless of the medium, figure painting requires drawing skills, so in part one of the book, I stress the importance of contour drawing. This is the best way to draw if you're new to figure work. At first you'll draw very slowly, keeping the pencil firmly on the paper. Later in this first section you'll speed up and start to develop a rhythm and a more flowing line. I hope you'll spend time in this section even if you feel you draw well, since the thinking required in contouring carries on into handling your brush and composing your pictures.

In part two I discuss the colors and other materials used in watercolor figure painting. I also deal with brush handling. You'll see that the spontaneity usually associated with watercolor is really only an illusion, and that the deliberation practiced in contour drawing carries right over into painting. I explain how to mix colors and deliver paint to paper properly, and show you some useful color combinations for painting flesh tones both dark and light.

Part three is concerned first with rendering accurate figure silhouettes and then with learning how to add shadow shapes to create the illusion of three-dimensional form. I also address ways to deal with the problems of figure proportions and foreshortening. Finally, I discuss how to approach figure subjects in terms of light and dark and introduce the idea of painting the *light* instead of the person.

The next section is devoted to drawing and painting the features. In almost all cases, figure paintings depend on the facial features as a starting point for establishing overall proportions as well as gesture.

Part five contains a series of step-by-step demonstrations that show how to paint a nude and a clothed figure, and how to integrate figure and background.

Section six is about composition and picture making. My compositional ideas are based on those of the Postimpressionists, who basically tossed out the conventions and rules associated with composition. I feel that the whole picture is important and that there shouldn't be a "center of interest." Good composition is based more on the placement of values and pieces of color than on the placement of figures or objects.

Note that in most of the step-by-step demonstrations throughout the book, rather than stop to photograph each stage of a progressive sequence and risk losing my concentration, I've made a different piece of art for each step. This accounts for the inconsistencies you may notice between steps.

CHARLIE PARKER *(detail)*
Strathmore cold-pressed paper,
22 x 22" (55.9 x 55.9 cm),
courtesy Electra Records

PART ONE
CONTOUR AND
GESTURE DRAWING

GETTING STARTED WITH CONTOUR DRAWING

One of the best ways to learn about rendering the figure is through contour drawing, in which your pen or pencil stays on the paper at all times as you concentrate on your subject. Contour drawing is all about seeing shapes, and thus requires an understanding of geometry. You must be able to gauge line directions, angles, and distances between points with your eyes so that you can draw the surface shapes of your subject. Here are the basic guidelines:

1. Concentrate.

2. Keep your pen or pencil on the paper at all times.

3. Draw slowly in small, contained areas and more quickly when you get to larger forms.

4. When you come to overlapping forms, let your pen or pencil leave the form you're drawing (but not the paper) and travel into the new, adjoining form.

5. Consider each completed form your measuring tool for the next form.

6. Bridge and connect each form to an adjacent one. Sometimes there is no form to follow, meaning you have to invent one (sounds confusing, but the demonstrations should make this clear).

7. Transfer yourself to your subject; think of your pen or pencil as actually being on the form you are drawing.

At first you'll feel stiff and clumsy, with your pencil traveling at an ant's pace, but with practice you'll start to develop some tempo. In small, contained areas the pencil will move very slowly because you are concentrating so deeply; then, when you get to larger forms and more open ground, the pencil will go faster. Wait and see.

Initially, we draw to understand and become one with our subject, and draw *exactly* what we see; every detail seems equally important. Eventually we must begin to edit, but for now, let's just concentrate on drawing what we see.

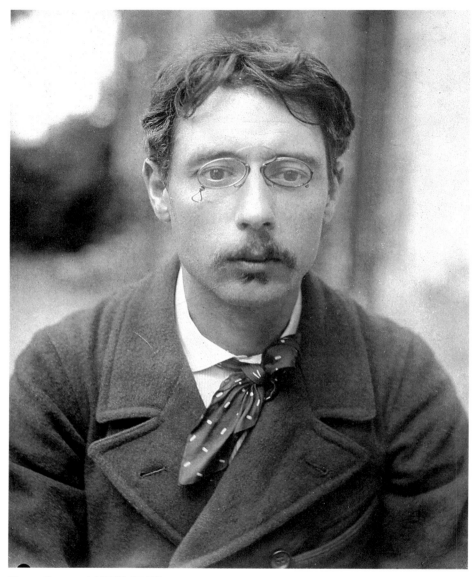

Pierre Bonnard (1867–1947).

For this first lesson, we will be working from a photograph of the French painter Pierre Bonnard (1867–1947). We'll start with a contour drawing of his right eye (in the photo, the eye at left); I usually begin here, perhaps because I'm right-handed. (When working from a model in a three-quarter pose, I start with the eye that's closer to me; if part of the face is in shadow, I start with the eye that's out in the light.)

Following the method I described in my introduction, I made a separate piece of art for each step in this sequence. The path in a contour drawing may differ with each attempt, so don't think there's one "correct" route.

The materials you need are an 11 x 14" all-purpose sketchpad and a fine-point pen; I'm using a ballpoint drawing pen. I want you to use a pen so you can't correct. You learn more by making a new drawing than by correcting a faulty one.

 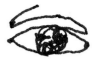

Starting in the iris, make a circular boundary and add little squiggles for shading. Don't fill it in completely.

Continue to the inside corner and around the lower lid.

Without lifting the pen, draw the beginning of the upper lid.

Move the pen up and around and the eye is finished.

Now move into the flap of skin above the eye.

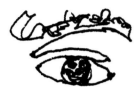 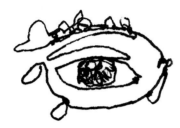 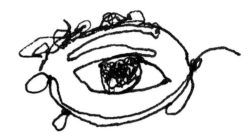

Draw up to the rim of the glasses and eyebrow.

Remember, DON'T pick up your pen when you leave one form (eye) and start a new form (glasses). In contouring, we don't make distinctions between forms because of their identity; the pen just keeps traveling.

I finish Bonnard's right eye and must cross over to his left eye and glasses rim. There's no form line to follow, but I don't lift the pen. Drawing slowly, I make an imaginary line, using part of the eye I've just drawn as a tool to measure the distance my pen has to travel. In this case, I think the distance to the left rim is about the same as the distance from the right side of the iris and inside eye corner.

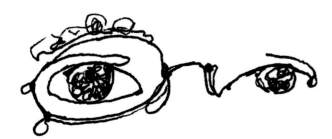 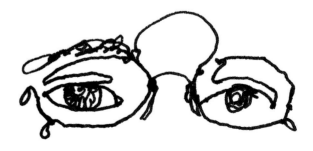

To draw Bonnard's left eye, I repeat the procedure I used for his right eye.

My pen travels out to the rim of the glasses, up and over the bridge, and back to the first eye.

USING THE DOT-TO-DOT APPROACH

Contour drawing helps us see and concentrate. It lets you learn how to draw something and brings you to a point where you no longer think about what you're doing. Drawings begin to draw themselves; drawing becomes intuitive.

As I contour, I don't plan or think ahead about what boundaries I'll use and which ones I'll ignore. That would distract me from my wish to be completely involved in my subject.

Have you done several drawings of Bonnard's eyes? Have you been able to concentrate? Has your pen stayed on the paper without skips? If you're having trouble, try drawing from dot to dot. Most of the features seem to be curving lines, and it's easy to go astray. In the dot-to-dot approach, you work only with angles, and no rounded, curving lines. As you draw, each time you encounter a directional change, stop and make a dot with your pen (but don't lift your pen). Check for the change in direction and judge the distance your pen must travel. Think of the lines you make between dots as "legs," which may be quite long where parts of your subject are straight and shorter where you are describing smaller, curving forms.

Contouring takes lots of concentration, and you'll probably have to do several drawings before you can stop working from memory and preconceptions. I made these five drawings of Bonnard by using a modified version of the dot-to-dot approach, making dots mainly where I needed reference points so I wouldn't get lost.

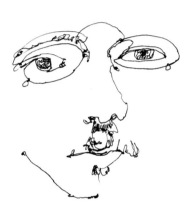

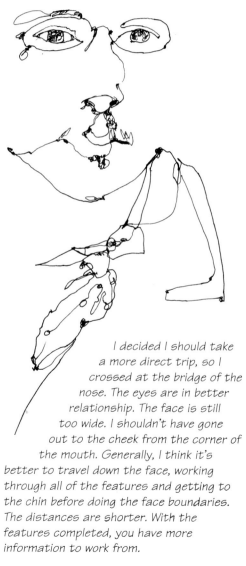

My first effort. The face is too wide because the eyes are too far apart. I tried to connect the eyes with the bridge of the glasses and traveled too far. If you make a mistake with your proportions in the beginning, everything that follows will be out of proportion. Remember, in contouring you use each previous statement as your guide to the next one.

I decided I should take a more direct trip, so I crossed at the bridge of the nose. The eyes are in better relationship. The face is still too wide. I shouldn't have gone out to the cheek from the corner of the mouth. Generally, I think it's better to travel down the face, working through all of the features and getting to the chin before doing the face boundaries. The distances are shorter. With the features completed, you have more information to work from.

I'm closer, but I was careless when I got to the chin. Notice the skip of my pen where it left the paper, which shows I went too fast. I made the chin too general and missed the specific angles there.

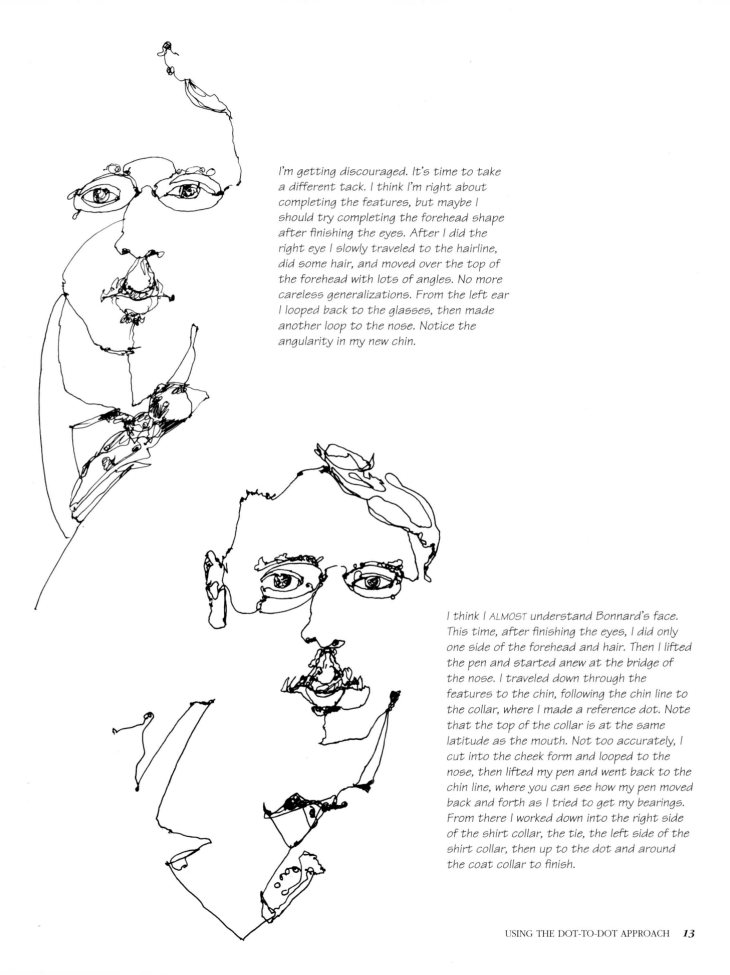

I'm getting discouraged. It's time to take a different tack. I think I'm right about completing the features, but maybe I should try completing the forehead shape after finishing the eyes. After I did the right eye I slowly traveled to the hairline, did some hair, and moved over the top of the forehead with lots of angles. No more careless generalizations. From the left ear I looped back to the glasses, then made another loop to the nose. Notice the angularity in my new chin.

I think I ALMOST understand Bonnard's face. This time, after finishing the eyes, I did only one side of the forehead and hair. Then I lifted the pen and started anew at the bridge of the nose. I traveled down through the features to the chin, following the chin line to the collar, where I made a reference dot. Note that the top of the collar is at the same latitude as the mouth. Not too accurately, I cut into the cheek form and looped to the nose, then lifted my pen and went back to the chin line, where you can see how my pen moved back and forth as I tried to get my bearings. From there I worked down into the right side of the shirt collar, the tie, the left side of the shirt collar, then up to the dot and around the coat collar to finish.

Putting Contour Drawing into Practice

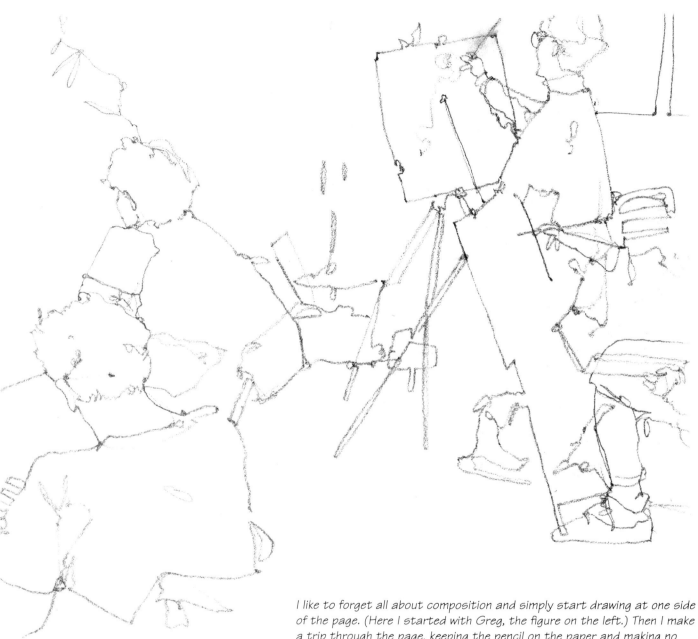

My Class at Hilton Head
*FaberCastell Blackwing carbon pencil
on Fabriano cold-pressed paper, 18 x 19"
(45.7 x 48.3 cm).*

I like to forget all about composition and simply start drawing at one side of the page. (Here I started with Greg, the figure on the left.) Then I make a trip through the page, keeping the pencil on the paper and making no erasures. I lift my pencil when I get to a border (in this case, at the upper left), then go back for a new start in one of the figures I've already drawn. Never start out in an empty part of the page. Instead, restart in an already-drawn form; this helps you keep correct proportions. I work right across the page, not worrying in the least if some of the figures are chopped by the picture border.

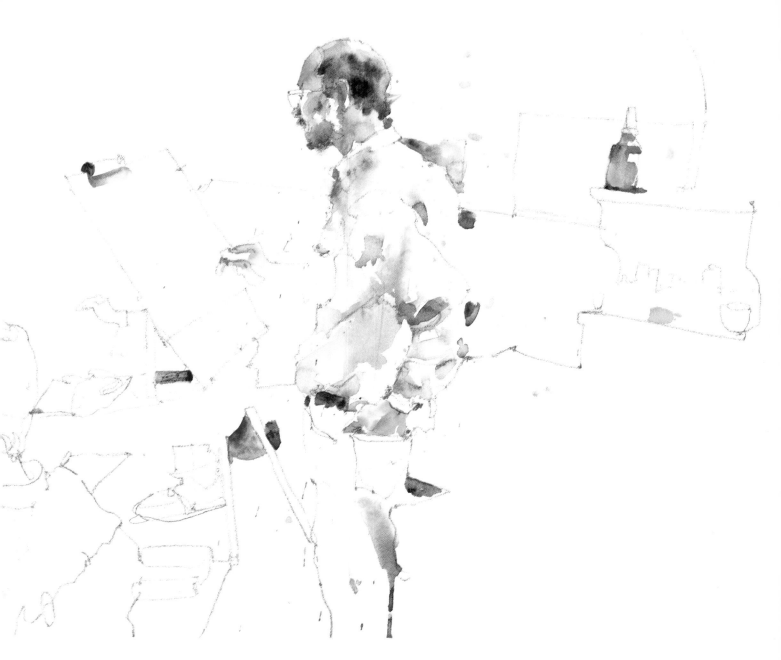

DAVID, HILTON HEAD
FaberCastell Blackwing carbon pencil and watercolor on Fabriano cold-pressed paper, 17 x 26" (43.2 x 66.0 cm)

I started in David's face and worked over to the easel, then moved on to the figure of Greg on the left. Then I went back for a brief trip out to the picture border on the right. Notice that I didn't finish all of the boundaries in ANY parts of the picture; the French easel is a good example. I left all important lights as white paper (the white in the beard, on the front plane of the face, and on the rim of the ear). I started my painting with David's nose, which is where I always start in a side view; it's the most important form within a face seen in profile.

Developing Bulk and a Third Dimension

Contouring is a wonderful way to draw, but it has some failings when it's time to paint. Contour drawings can look flat, with some forms outlined and separated from neighboring areas. The best way to decide if an area is isolated is to squint at it. If a boundary is hard to see when you squint, it should probably be "lost." If a boundary appears definite when you squint, it should probably be kept, or "found." Losing and finding boundaries or edges helps suggest form and bulk and is a critical step in painting.

In this lesson, which is also based on the photograph of Bonnard that appears on page 10, I've darkened areas that have obvious contrast with a neighboring lighter area, making a more definite found edge or boundary between dark and light. I've erased boundaries or used a lighter line between areas of similar or compatible value (relative lightness or darkness), creating a lost edge. The next step is to plan darks and define shadow shapes; we need to add darker values in carefully selected areas to enhance the sense of form.

When viewing any subject, always ask yourself, Where's the light coming from? Sounds obvious, but the trouble is, you might not even think about it. Light plays a major role in this book. In the photo of Bonnard the light is very subtle, but if you look hard you'll see that it's coming from the left. Invert the book and look at the photo upside down; it's easier to see that the right side of the face is slightly darker than the left. The real darks are in the features and hair, with only subtle shadows on the face itself.

In developing three-dimensional form, this is my basic drawing technique: I begin with a contour drawing, then plan my shadow shapes and add *mapping lines,* which give me specific shapes to fill in. Specific, accurate shapes are essential in describing physical forms and light and shadow. With shapes in place, I add shading, making pencil strokes that are *diagonal* in relation to the features and my mapping lines. I wouldn't have as much control over the shapes of the darker areas if I shaded with strokes that were parallel to my mapping lines. Such parallel strokes can look scratchy. Note in the two finished drawings that my shading lines don't all go in the same direction. Keep a sense of variety in your strokes.

For this exercise you will need a sharp #2 office pencil and a kneaded eraser.

Step 1. *I've done another contour drawing of Bonnard, this time using a #2 office pencil.*

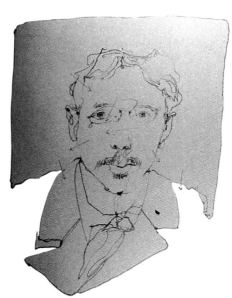

Step 2. *Squinting at the photo, I have a hard time seeing the inner corners of the eyes, cheek boundaries, sides of the nose, and coat boundaries. With my kneaded eraser, I erase DIAGONALLY through these boundaries. Keep comparing what is easy to see with what's hard to see.*

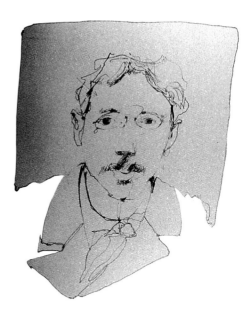

Step 3. *I've darkened the places where contrast is apparent—where the difference between lights and darks is more obvious. Good pictures are made up of contrasts: the definite and the vague, the strong and the subtle, the obvious and the obscure.*

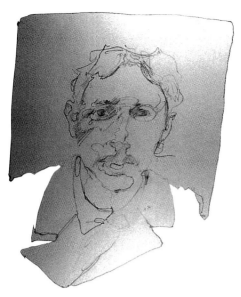

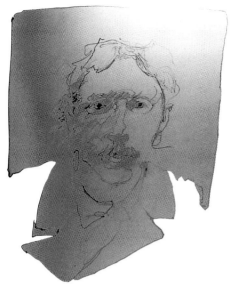

Step 4. I've erased some of the shading I added in the preceding step and have made outlines around darker parts. You can see how I've started mapping my shadow shapes and darks. Normally, we think only of the features as we admire our subject. In order to paint, we must admire the shapes of lights and darks, because these are the means for making the features come alive.

Step 5. I'm adding shading ACROSS the form beginning in the eye sockets and on the left side of the face. These diagonal lines pass over shadow-planning lines where I have an indefinite form above the bridge of the nose. Under the glasses I have a very definite boundary. My shading lines stop abruptly at the planning line to make a hard division between the light in the cheek and the dark in the lower part of the glasses. We're drawing shadow shapes, NOT the features. As I work down the left side of the face, the shading lines cross over my mapping lines and the outside boundary of the face. This suggests softer edges.

Step 6. As I get down around the nose and mustache, I bear down with the pencil, because the values here are darker than in the cheeks. The darks under the nose merge with the mustache and mouth. My shading lines on the left cheek cross over and tie into similar values behind. Where dark meets light— where the ear meets the background—I make sure I have a crisp edge. I don't want darker background values to destroy the shape of the ear. Where two contrasting values meet, you have a crisp edge. Where two similar values meet, you have a blurred edge. Squint if you're in doubt.

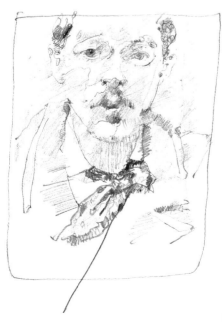

Step 7 (finish). The completed drawing should look a bit unfinished. Get into the habit of defining just a few areas and leaving others vague. I have definition in the right ear and in parts of the eyes, nose, mouth, and neck.

Here is a second version. I've chopped off the top of the head because I placed my beginning forms too high and ran out of space. Never crowd a subject into the picture if you've planned badly. It's better to keep good proportions and let the problem area drift out of the picture space.

Contouring with Pen and Wash

In the previous lesson we planned shadow shapes and darker forms in pencil, outlining these darker shapes with a pencil boundary. Next, we squinted at our subject, making less significant details harder to see; we then erased the harder-to-see boundaries. We used diagonal pencil lines to create darker shapes, giving Bonnard's face mass and bulk. I wanted you to see and contour Bonnard's features, despite the subtlety of contrast in the reference photo that made shadow shapes difficult to see.

For this lesson I've switched to a photograph that has obvious light and dark shapes. Our subject is Kiki, a model and friend of such artists as Picasso, Modigliani, Man Ray, and Pascin and a much-loved member of the bohemian community that thrived in Paris's Montparnasse quarter during World War I and the 1920s.

Here we'll make our drawing with a water-soluble pen instead of a pencil. We'll plan our darks, using a boundary to map their sizes and shapes, then add diagonal lines for our shadow shapes.

You'll make your shading lines closer together when you want a dense dark; the closer the shading lines, the darker the value. When you want a middle value, you space the shading lines farther apart, making the distance between them even wider when you want just a suggestion of tone. You will add a wash to your drawing with a small pointed brush dipped in water, using the pen lines as your pigment instead of watercolor paints. You'll see that the amount of water you use affects the darkness of the shadow shape.

The materials you need for this lesson are a fine-tip pen with water-soluble ink (I'm using a Reform Quicktip disposable pen), a #2 pencil, a #3 or #4 round watercolor brush, water, and an all-purpose sketchpad or watercolor paper.

The Parisian model Kiki.

Too often we assume horizontal features, but our model's right eye is slightly lower than the left. ALWAYS CHECK FOR TILT. Start with the upper part of the face. Draw in what you're able to see of the eyes and the boundary of your shadow shape and add diagonal shading lines.

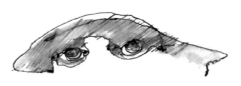

I've made just one pass with my brush, and some of my shading lines remain.

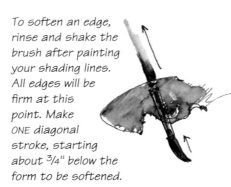

To soften an edge, rinse and shake the brush after painting your shading lines. All edges will be firm at this point. Make ONE diagonal stroke, starting about ³⁄₄" below the form to be softened.

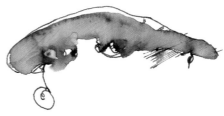

Dip your brush in water, then give it a good shake. Start your stroke where the edge of the shadow meets the light. NEVER start a wash within a shadow and work outward; you're bound to fudge a shape. SLOPPY SHAPE BOUNDARIES DESTROY THE FORM.

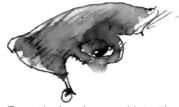

On my second pass, I lose the shading lines. I've softened one edge under the right eye. (I used a bit too much water—my shadow value is almost too light.)

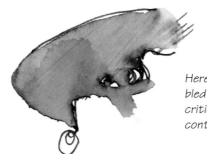

Pass the brush up and into the shadow form. Lift the brush. This creates a path allowing a small section of the shadow to escape. Don't work the edge after making the single pass. Let the water and ink do the work. This takes practice.

Here I used too much water and my wash bled too much. The right amount of water is critical. Too much water makes you lose control and results in a washed-out picture.

Placing Features Correctly

Let's go a step further and work on getting the features in the right places. We'll start with the same shadow shape of the upper part of Kiki's face that we used in the preceding lesson. Be prepared to make several tries, aiming for a cogent, descriptive shape with a good, definite value (not too dark and dense, but not too light and vapid).

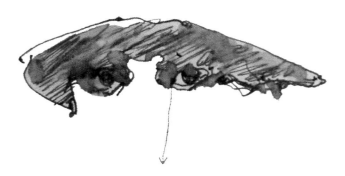

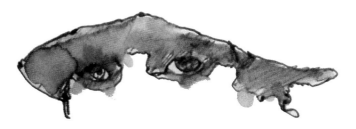

I'm unhappy with this drawing; it seems bland and washed out. My brush was probably too wet. (Be sure to give your brush a good shake after rinsing.) As you proceed with this lesson, you'll make mistakes, so do three or four versions of this step.

Step 1. *This one has more verve. It's best if you don't paint out all the shading lines. Here's how to place the nose. Study the photograph. The outside edge of the left nostril is directly below the inside corner of the left eye. With a pencil, drop a vertical line from the inside corner of the left eye. Make a dot when you think you've reached the nostril, but continue the line in case you've guessed wrong. You can always erase if you go too far. Keep the pencil on the paper with a single line. No sketching.*

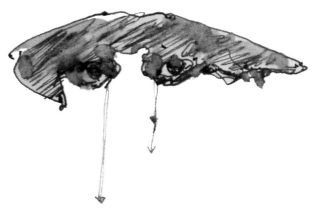

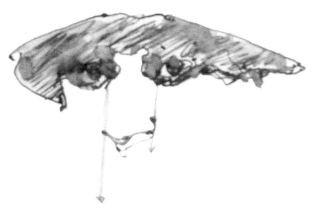

Step 2. *Now drop another line from the inside corner of the right eye. Check the photo; you'll see that this line hits the tip of the nose.*

Step 3. *Go back to the dot you made in step 1 and see if you've placed the nostril far enough below the eye. With your sharpened pencil, carefully form a shadow shape using the vertical plumb lines as guides. If you've made the nose too short or too long, don't erase. It's always better to continue.*

Step 4. *In the photo, study the subtle halftone on the left nostril and the side of the nose. After checking the proportions of the shadow shape you drew in pencil under the nose, draw a new shape over it in pen, combining shadow and cast shadow as one piece. Then make your shading lines. Rinse and shake your brush, then paint the shadow shape. Let some shading lines remain. To soften, place your brush so it partially overlaps the top of the shadow shape at the tip of the nose and make a 1/4" stroke. Keep your brush on the paper until you*

finish the stroke; no dabbing or lifting. I run my brush parallel to the shape for 1/4", then head north without lifting, painting around a small light on the nostril, then moving down to soften the far side of the nostril. Then I head up toward the eye.

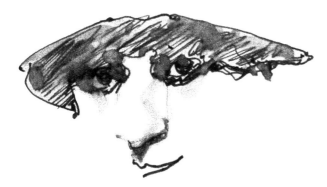

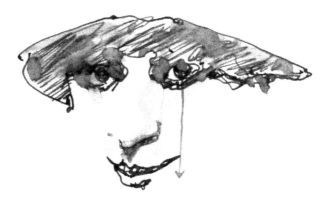

Step 5. In the photo, the left corner of Kiki's mouth is almost directly below the lower rim of her left iris. The right corner of her mouth is below and just to the left of the nose tip. I start my outside contour of the mouth where it almost hits the nose's cast shadow. Drawing very slowly, I try to capture the upward curve of the upper lip. It's hard to know how far to go. I backtrack and draw the lower part of the upper lip.

Step 6. I make my vertical line. Now I know how far it is to the corner of the mouth. Keeping my pen on the paper, I backtrack and complete the lower lip.

Step 7 (finish). I add shading lines and paint the mouth, leaving light in the lower lip and making sure I don't stray outside the mouth's contour. I soften once beneath the lower lip and once at the corner with single, diagonal strokes. Don't soften all your edges; otherwise the image will look mushy. Some hard edges provide substance.

COMMON MISTAKES AND HOW TO AVOID THEM

Getting features in the right place can be very difficult when the head is tilted and turned away from you. We tend to imagine the face in a more "normal" position and adjust the features to suit it. In this example, I aligned Kiki's features as if her head were level, and brought them into the center of her face as if she were turned completely toward me. I also lowered the shoulder line, as if Kiki were at eye level instead of below it.

It's very easy to "normalize" a pose. Here, I've pulled the model's body into a front view and extended the far shoulder, so that both shoulders have become almost equal. (Students often do this, pulling the far shoulder toward them.) I've also lowered the shoulder line, making it strike just at the chin line.

Refer back to the photograph of Kiki. Lay a Lucite drafting triangle on the inside corner of her right eye (as in this illustration), making sure the edge is vertical. Note where the tip of the nose, corner of the mouth, and chin are in relation to the corner of the right eye.

After completing the eyes and making sure they have a slight tilt, I check the distance from the outside corner of the right eye to the boundary of the face, then compare it with the much longer distance from the outside corner of the left eye and through the shadow to the back of the head. This distance is harder to judge, but if you come relatively close to getting it right, you'll have the eyes in proper relation to the boundaries of the face and head. Check the shoulder line in relation to the eyes, the earring on the left, and the hat brim on the right.

Here's the pose we're aiming for. Compare the shoulder line with those in my "mistake" drawings opposite. Note how little of the far shoulder actually shows. The closer shoulder strikes the model's face at her ear, the far shoulder at her earring. The features and shadow shapes in the face are the critical reference points for establishing the placement of the shoulder line, which, in turn, is crucial to capturing gesture. Check the far side of the body. It's INSIDE the vertical line dropped from the hat brim. The V-shaped sweater neckline is to the right of the line dropped from the cheek.

In summary, each new feature or form is dependent on the proper placement of the feature or form drawn before it.

GESTURE DRAWING, FRONT VIEW

I use contouring in all of my drawing, even with short poses in sketch class. I think it's the best way of drawing, but it's hard to do if you're new to life drawing and you're presented with one- to five-minute poses. Short poses are often dynamic and complex, and you'll find yourself never getting beyond the head and shoulders.

Let's put contouring on the back burner for the moment and look at longer, more flowing lines that connect forms in distant parts of the body. The line of the neck can flow to the hip and on to the lower leg. If these longer relationship, or gesture, lines are drawn at the correct angle in the correct place, they'll capture the pose. It's interesting that most poses get their character from just two or three lines. At first, you'll have to sacrifice shape and instead concentrate on the angles of these lines in relation to one another. As you progress, these lines will come automatically, and you won't actually put them on the paper. You'll understand the dynamics of the pose and can concentrate on the shapes that make figure drawing so fascinating.

In contouring, we keep the pencil on the paper at all times. In gesture drawing you'll lift the pencil from the paper as you cross over forms, actually drawing in the air before once again connecting with the paper as you find a relationship.

This lesson and the two that follow are meant to show you the natural relationships among the various parts of the body. As you draw, try to be graceful and try to develop rhythm. Use your whole arm. Practice varying the pressure on your pencil, lifting and then pressing down as you draw.

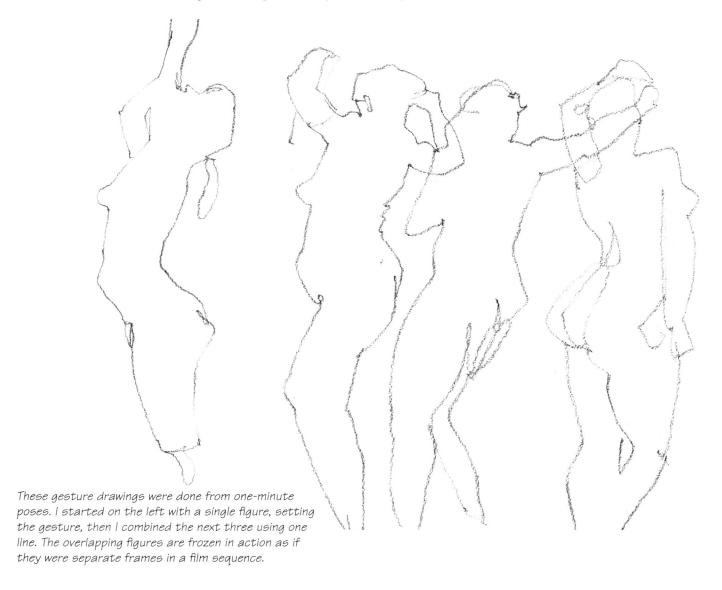

These gesture drawings were done from one-minute poses. I started on the left with a single figure, setting the gesture, then I combined the next three using one line. The overlapping figures are frozen in action as if they were separate frames in a film sequence.

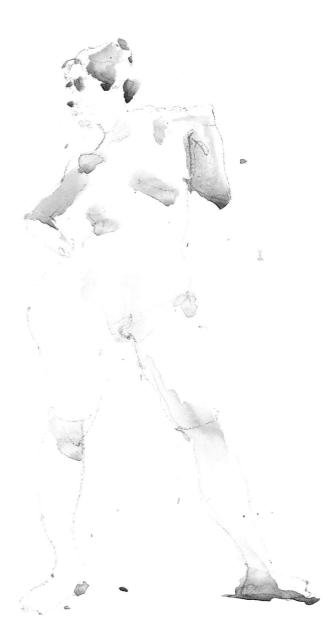

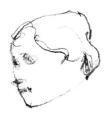

Step 1. *The model's head is turned in almost a three-quarter view above my eye level. I suggest starting with a triangle made of gently curving lines. The eyes, underside of the nose, and mouth are drawn with delicate oval strokes. Don't use hard lines; we only want to establish feature placement, not details. Make sure the closer eye is higher than the far eye. The hairline curves fairly near the closer eye; draw the hair as a shape where it meets the neck and chin line. This is an important reference point.*

This is my reference drawing, which I did in a recent sketch class. You can ignore the washes I added; just concentrate on the line drawing.

Step 2. *The shoulder line is the first important action line. Its angle and placement in relation to the head is the key. If you're off here, the whole gesture will be wrong. In this pose, the shortest distance from the head to the shoulder line is the back of the neck. (Be sure the hair behind the neck is placed correctly in relation to the chin line.) Make a short jog down from the intersection of the hair and neck, then stop, check for angle (which should be about 90 degrees), and draw over to the tip of the shoulder, making this line just under a head's length. Stop, make a dot, then draw an acute angle down and toward the left, lifting the pencil at the end of the stroke.*

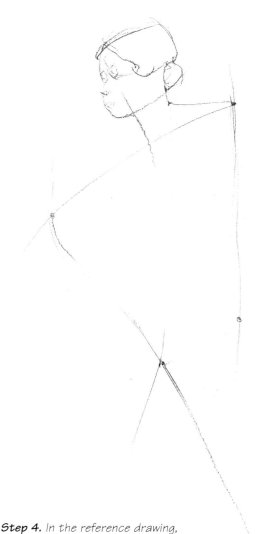

Step 3. Draw the front of the neck. Starting at the closer eye oval, make a line parallel with the back of the neck. Try starting your line before making contact with the paper, stroking with a smooth, easy motion using your whole arm and keeping your wrist firm, then lifting the pencil as you pass the shoulder line. (This is the motion you should use throughout the drawing.) The right side of the figure is made with a vertical line starting at the point of the left shoulder. Don't worry too much about length; try to make this line longer than you think necessary. Go back to the point of the shoulder, measure about 2¼ head lengths down your line, and make a dot. This is the upper hip bone.

Step 4. In the reference drawing, the crotch is about 2½ head lengths below the back of the neck. Begin your next stroke in the air as a slightly curving line, touching pencil to paper only when you reach the lower torso. Continue down the paper and lift. Mark a point on this line indicating the crotch. Next, make a dot on the left side of the shoulder line 1½ head lengths from the neck. Starting in the air, make an S stroke without touching the paper, aiming to pass just above the crotch dot. When you have the feel, try it again, hitting the paper with the pencil just above the elbow dot; lift and hit the paper again, passing the line through the crotch dot, straightening the line and continuing it for 3½ head lengths. Lift your pencil.

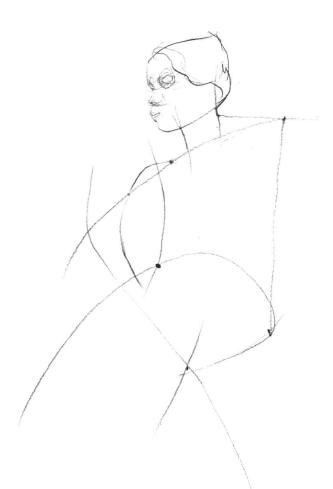

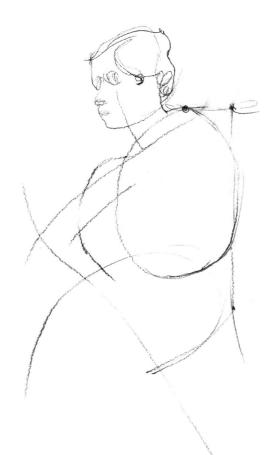

Step 5. In one flowing motion, draw a very light line from the hip over to the crotch; stop and, lifting the pencil slightly, make a loop back toward the left hip, continuing up and over and returning with some pressure to show the right hip. We can draw the right shoulder and the inner lower arm with one line. Study the reference drawing and make a dot just to the right of the neck. Make an abrupt curving line that becomes parallel with the lower arm line you've already drawn. Make another curving line; start above and move through the shoulder form you've just drawn and intersect with the hip. Make a dot.

Step 6. Add the rib cage. Make a dot somewhere on the shoulder line near the back of the neck. To establish the oval form of the rib cage, do some dry runs first without touching the paper. When you've gotten the feel and are ready to put pencil to paper, as you make your stroke, see if you can hit the dot you just made and the dot on the right hip. Draw the rib cage, lifting a bit on the right side and continuing to your starting point. Add the lower side of the upper arm.

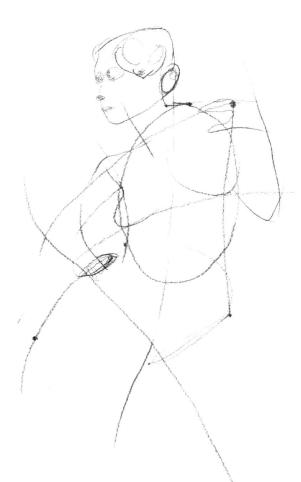

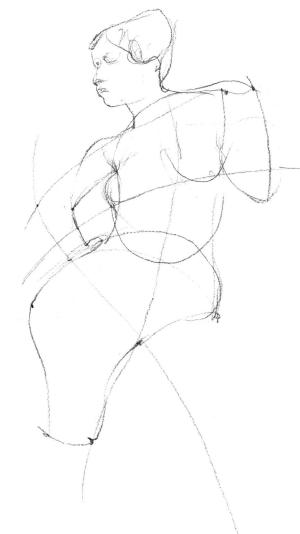

Step 7. *Lightly draw a line above and parallel with the right hip. Add the breast forms using the curving line as a guide. The curving line crosses from the torso into the lifted lower arm just as it tapers down to the elbow. (The lower arm at this point is about half a head's length.) The elbow is a simple triangle; draw up to the wrist and hand, meeting the shoulder line. Make a flat oval to show the hand on the right hip. About a head's length down the right hip line, make a dot. Study my reference drawing. How many head lengths are there from the hip dot to the outside of the knee? Where would you place the outside of the right knee in relation to the right arm?*

Step 8. *I know you've gotten the measurement and placement; now you just have to draw an elegant curving line to the outside of the knee, cross over the kneecap, and then travel happily upward with an S-curve to the dot on the left hip. Notice how this curving line weaves through but doesn't repeat the old line from step 4. The old line is only a guide to help with a new line. I've stopped at the knee and completed the upper leg to keep track of my proportions.*

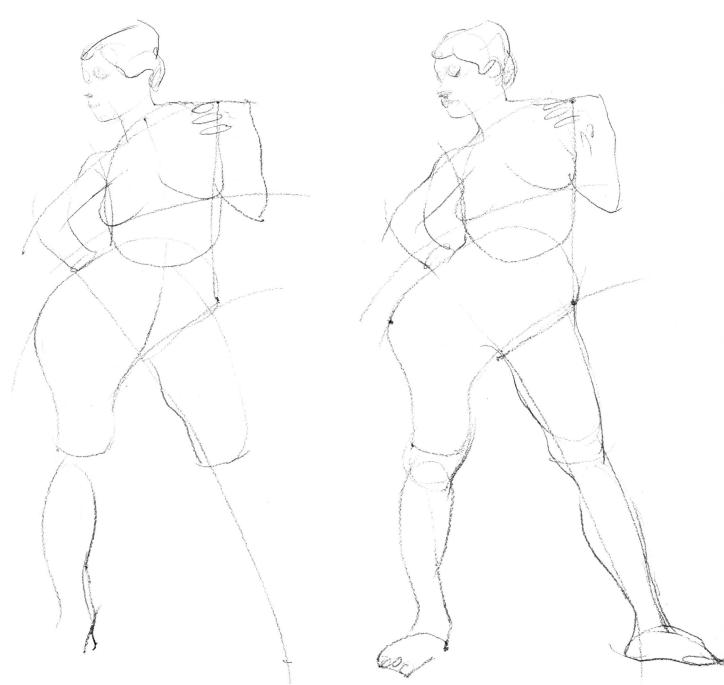

Step 9. Let's finish the right lower leg. I left the knee incomplete so you can see the relationship lines. I draw down the inside of the right thigh with hardly any pressure, then lift the pencil, hitting the paper again with a curving line describing the outside of the lower leg. Have you noticed relationships between the opposite sides of forms? Starting with my pencil in the air, I backtrack up and around to show the inside of the calf. The straight "bony" part relates to the outside of the upper leg. Next, I make a short jog for the ankle. I shape the left upper leg, and stop at the knee.

Step 10 (finish). I build the calf form on the old line from step 3 (this is why we don't erase). Note that the outsides of the lower legs are gentle curves, while the insides are stronger. The tops of the feet are drawn with lines curving from the heels through the ankles. Ovals suggest fingers on the left hand. Two separate shapes form the upper arm: the deltoid (shoulder muscle) and the triceps/biceps area. Connect the two with a new, flowing line starting at the neck, redrawing the boundary of the shoulder and upper arm.

Gesture Drawing, Back View

In the previous lesson, we used relationship, or gesture, lines to understand the natural connections among different parts of the body. These relationship lines also formed a sort of skeleton as a basis for our figure. Before going further, be sure you understand how lines describing a form in the upper body can be continued into the lower body to find new forms. Never look for a formula. Sometimes the neck line will pick up the hip, sometimes it won't; the relationships change with each pose. You must understand the principle of relationship drawing so you'll be able to find your own connections.

In this back view, I start with the head form and then use the angles and shapes in the hair to develop the shoulder line. The head and shoulder line become my source for the rest of the figure. It's the same concept we followed in contouring. Instead of "sketching," we're aiming to make single, meaningful lines. We're still comparing and relating, but the relationships can be on opposite sides of a form and on opposite sides of the figure. (Remember how in contouring we worked only with adjacent forms?)

This is my reference drawing; again, you can ignore the washes.

Step 1. Draw a simple oval and build an accurate hair shape around it. Study the reference drawing and understand the very important angle of the shoulder line. IT MUST BE ACCURATE. First get the angle with a simple, continuous curving line. The hair shape suggests new relationships, refining the contours of the shoulder line. The right side of the hair can be continued into the left shoulder, while the left side of the hair can be related to the right shoulder.

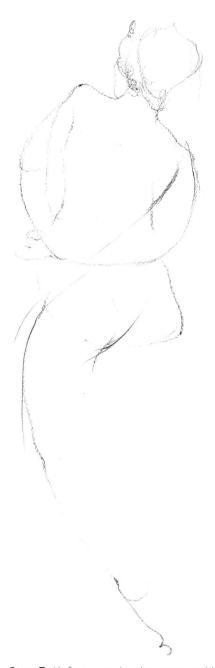

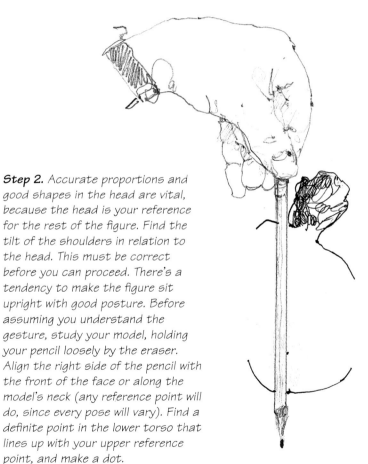

Step 2. Accurate proportions and good shapes in the head are vital, because the head is your reference for the rest of the figure. Find the tilt of the shoulders in relation to the head. This must be correct before you can proceed. There's a tendency to make the figure sit upright with good posture. Before assuming you understand the gesture, study your model, holding your pencil loosely by the eraser. Align the right side of the pencil with the front of the face or along the model's neck (any reference point will do, since every pose will vary). Find a definite point in the lower torso that lines up with your upper reference point, and make a dot.

Step 3. Unfortunately, the arms and legs are often thought of in terms of abrupt, angular joints. Here we see that the arms can be drawn and connected with graceful curves. After the shoulder line and curving arms, the next big relationship is an S-curve that can start up by the hair shape, then describe the right upper torso and upper arm, and then flow over to the left hip all the way to the heel and toe. Practice this curve. You must get a flowing line.

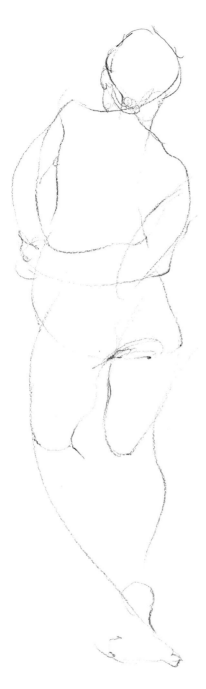

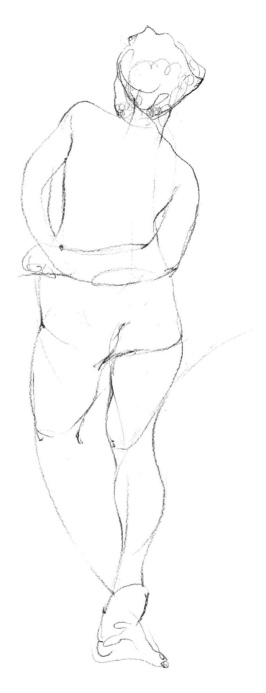

Step 4. *The gesture has been established in step 3. You should be able to manage this in a two- or three-minute pose; you've got the essence of the gesture with an economy of line. Joints can be good spots to stop to check proportions, especially with long forms like the leg. Drawing to the knee, I check the length of the upper leg, then cross over and, with a continuing stroke, draw up the other side. Shapes differ on either side of every form. The inside of each leg has two shapes, while in this view the outside is a single shape.*

Step 5 (finish). *As a general rule, relationships are found on opposite sides of forms or opposite sides of the body. Sometimes relationships are found on the same side of a form. Try to find an example of each in my drawing. In this case, the inside of the ankle and inside of the upper thigh relate to each other on the same side of the right leg. Another relationship exists between elements on opposite sides of this form: the inside of the right calf and the outside of the upper right thigh.*

GESTURE DRAWING, KNEELING FIGURE

This is essentially a contour drawing with only a few inside relationship lines. (The contour is faster, with more flowing lines than those seen in the earlier lessons. Also, the pencil is not always anchored to the paper with a constant pressure.) As you progress with your drawing, your pencil will lift when you wish to find a relationship that crosses over a form, and then makes contact again when you've reached your destination. In many cases, I make these relationship checks in my head while the pencil actually remains in the outside silhouette shape.

Two important relationships are obvious. The line dropped from behind the shoulder shows me where to place the front of the left leg. This makes a good case for drawing an accurate head, arm, and shoulder. Notice how important accuracy in the head shape is in helping to describe the upper torso, arm, and leg.

The woman is large. Closely study my reference drawing and notice the places where my pencil skipped as I lightly drew the oval forms that help me understand the bulk, but also the beauty, of the figure. It's hard to describe; I start with my pencil in the air, get some sense of what the figure is about, then pounce on the paper, trying to carve a line that captures a graceful shape before I lift the pencil.

Study the progression that follows on the next two pages. I've left out captions, hoping that the drawings alone clearly show how I found the gesture and character of the model.

We see only a part of the figure's face, so it's best to think of the arm and head as a single silhouette shape: Thus, don't draw the arm and head separately; instead, concentrate on capturing the shape of the silhouette accurately. You must understand the angles and distances that exist between forms. Once this silhouette is completed, the pencil crosses over to show the inside of the upper arm and the small form of the shoulder.

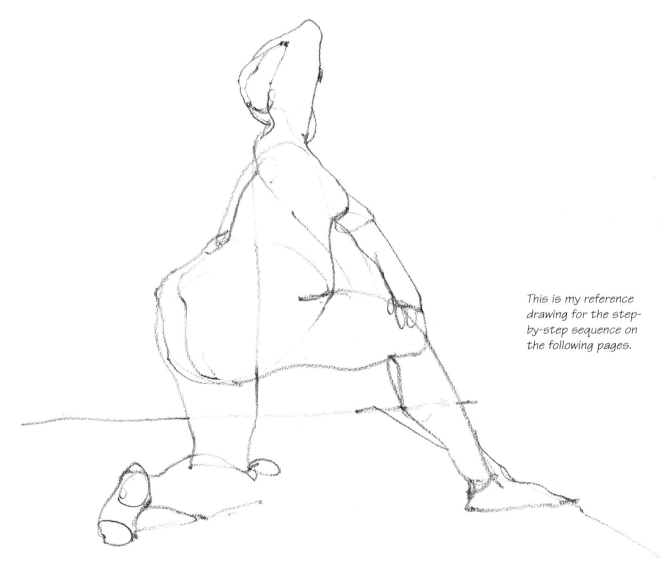

This is my reference drawing for the step-by-step sequence on the following pages.

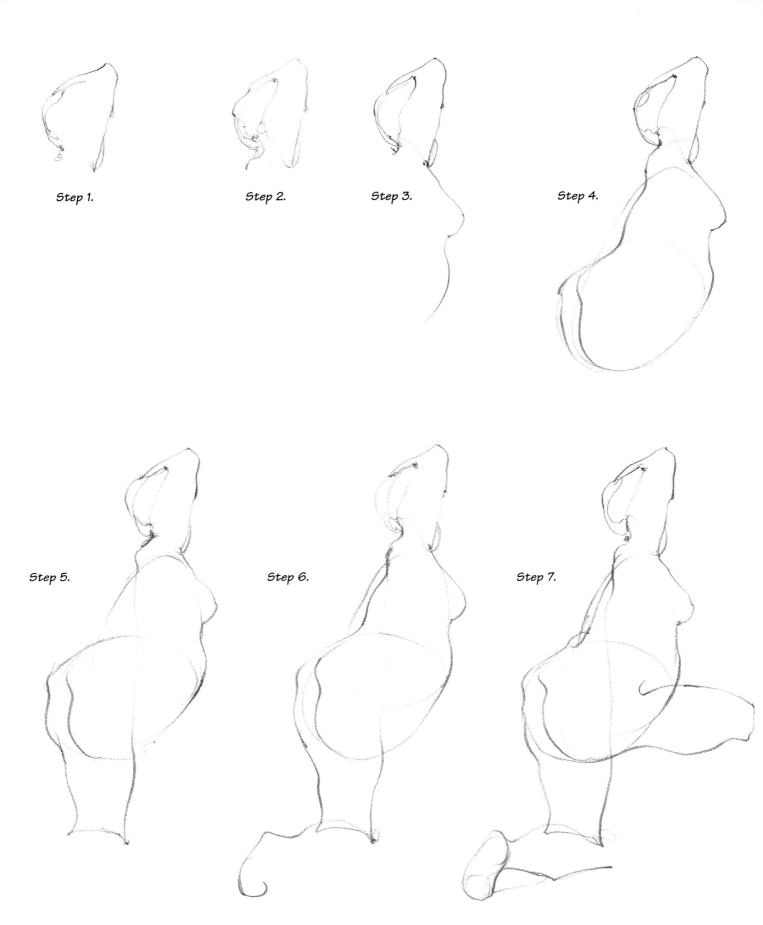

Step 1.

Step 2.

Step 3.

Step 4.

Step 5.

Step 6.

Step 7.

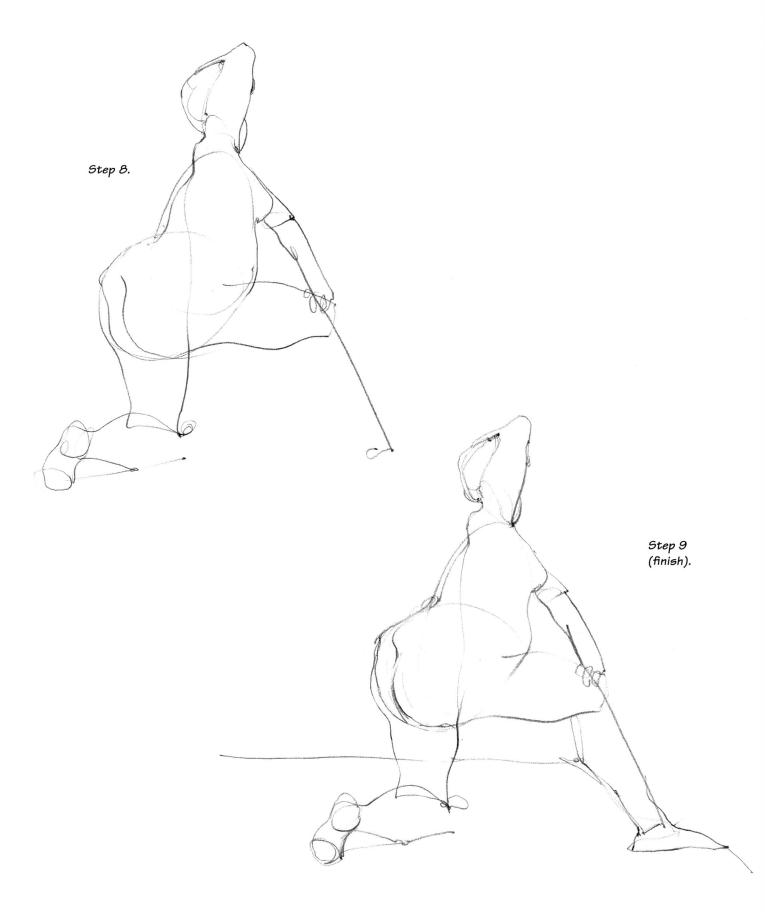

Step 8.

Step 9
(finish).

PART TWO
PAINTING
TECHNIQUES
AND COLOR

For Pete
from Paul 3·17·87

MATERIALS

The basic materials you need to paint in watercolor are pretty obvious: paints, a palette, brushes, paper, a container of water, tissues, pencils, a kneaded eraser, and a firm board to use as a working surface, plus clips or tape for attaching your paper to it. Here is just a brief overview of the most important items.

PAPER

I hate to recommend a particular paper, but Arches is probably a good starting point if you don't already have a favorite. It's sturdy and takes a good deal of punishment. The amount of sizing (a water-resistant coating added in the paper-making process) a paper contains determines how it will take a wash. It seems to me that Arches is quite heavily sized and that washes stay on its surface, making it easier to move your paint about. Papers made by Whatman, Winsor & Newton, Lana, and Fabriano seem more lightly sized, and some painters complain that they are too absorbent. That said, I'm not an Arches fan, since I learned to paint on Fabriano and am used to its characteristics.

Watercolor papers come in three surfaces: hot-pressed (smooth), cold-pressed (lightly textured), and rough. Most of the work in this book was done on cold-pressed paper, which is what you'll probably use most often, too. It also comes in various weights, ranging from a light and delicate 90-lb. to the medium and most useful 140-lb. to the very heavy 300-lb. A friend who knows a lot more about materials than I contends that the lighter the paper's weight, the more brilliant the color applied to it looks. Because I myself don't do much overpainting (glazing), I never use 300-lb. paper; however, artists who do a lot of glazing might find the sturdy 300-lb. weight necessary.

I don't stretch my paper but simply attach my loose sheets to a board with bulldog clips. This is because I don't prewet my paper as many painters do. If you prefer to work on prewet paper,

attach it to your board with masking tape on all four borders to stretch it first.

Watercolor paper is available in loose sheets (the standard size is 22 x 30"), rolls, and blocks of various sizes that are very handy for working outside the studio. You can also find cloth- or wire-bound watercolor sketchbooks with paper of various weights. Cloth-bound books have an air of importance and might encourage you to take more care with your work.

SELECTING PAINTS

Watercolor paints come in small and large tubes and in dry cake form called pans. You should start with tube colors, especially if you don't paint regularly, because you can simply squeeze out small amounts of fresh paint whenever you need it. Pans dry out and can be difficult to soften, especially the earth colors. On the other hand, they seem particularly brilliant and, when properly moistened, can deliver a lot of pigment. Boxes of cake colors are wonderful for sketching and come in a variety of convenient sizes. For some reason they are favored more in Europe than in the United States.

One of the most important things you need to understand about color is its *temperature.* Reds, yellows, and earth colors (yellow ochres, siennas, and umbers) are generally considered *warm,* while blues, violets, and greens are thought of as *cool* colors. Temperature is, however, a relative quality. For example, cadmium red and vermilion are considered warm reds, while alizarin crimson and carmine are cool; likewise, cadmium yellow is warm, while cadmium lemon and aureolin are cool. Among the blues, cerulean and phthalo are definitely cool, ultramarine relatively warm, and cobalt somewhere in the middle. Viridian is a cool green, Hooker's is in the middle, and sap and olive green are relatively warm.

Any given paint color can vary in both hue and value from one manufacturer to another. Yellows in particular seem to vary a lot in this respect, and in figure work it's especially important to check the

relative temperature of the yellow you're using, as you want a fairly warm one.

Consult manufacturers' color charts before buying paints, not only to make sure you're getting the hue you want, but also to check for its permanency and lightfastness rating. Fortunately, most of the standard colors you'll use are reliably stable and lightfast. Three exceptions are alizarin crimson, Hooker's green, and sap green, which generally fall below the top tier in durability ratings (although Daniel Smith Inc. makes a sap green that's rated extremely permanent). You can easily get along without these greens, but I find that I need an alizarin color. HK Holbein's carmine is very similar in hue to alizarin crimson and is rated absolutely permanent on the company's color chart. Winsor & Newton, on the other hand, rates its alizarin crimson as only moderately durable. Still, I find this to be the most useful red for mixing (cadmium red is opaque and seems heavy and dull by comparison) and have had no complaints of fading, so I'll continue using it.

Many watercolorists consider a color's transparency or opacity a prime factor in choosing paints. Again, since I use only a minimum of glazing in my work, I really haven't paid much attention to this. Alizarin crimson and phthalo blue are two transparent colors I do like for mixing, but these are about the only transparent colors I use.

A favorite combination of colors to use when mixing grays is alizarin crimson, phthalo blue, and a touch of yellow ochre; in this swatch I've used Holbein's carmine, peacock blue, and yellow ochre.

PALETTES

For the majority of my work I use tube paints and a folding enameled metal palette made by Holbein. Mine has 24 slant trays on which to lay out colors, five wells for mixing, and a thumb hole; closed, it measures 4¼ x 9¾". A similar Holbein model measures 5½ x 12" and has 22 slants and four wells. These palettes are expensive, but I've never enjoyed plastic ones. Currently, however, they are hard to find. Perhaps if you pester your art supply dealer, Holbein will be encouraged to make some more.

For traveling and sketchbook work, I use half-pan cake colors in a watercolor box made by Daler-Rowney; mine holds 16 colors, has three wells and a mixing tray, and measures 5 x 2⅞" when closed.

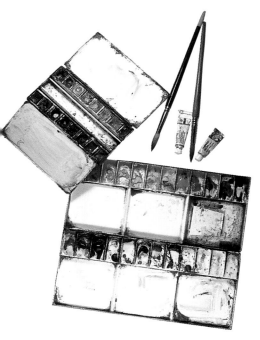

The larger of my two palettes is made by Holbein and is for my tube colors; the smaller one, which I use for travel and sketchbook work, is made by Daler-Rowney and contains half-pan cake colors. (These are, left to right, top row: cerulean blue, cobalt blue, ultramarine blue, phthalo blue, viridian, ivory black, burnt sienna, and burnt umber; bottom row: alizarin crimson, cadmium red, cadmium orange, cadmium yellow, cadmium lemon, yellow ochre, raw sienna, and raw umber.)

COLOR ARRANGEMENT

You don't need a lot of colors to get started in figure work. A good range to begin with is a limited palette of just six hues: alizarin crimson, cadmium red, cadmium yellow pale, raw sienna, burnt sienna (not for flesh tones), and cobalt blue. Normally I work with an extended palette of about 15 colors excluding greens, which I rarely use in figure painting. My full palette consists of 18 or so colors and does include a green. Study the illustrations to see which colors I use and how I lay them out in each case. I think my recommendations are safe choices most painters could live with, yet I know that other artists I admire would select different colors. (*Everything You Ever Wanted to Know About Watercolor,* published by Watson-Guptill, offers lots of color selection ideas by several excellent painters.)

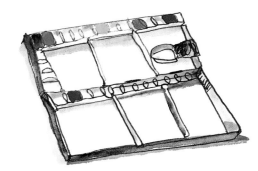

Limited Palette
alizarin crimson
cadmium red
cadmium yellow pale
raw sienna
burnt sienna
cobalt blue

Extended Palette

alizarin crimson	*burnt sienna*
cadmium red	*burnt umber*
cadmium orange	*ivory black*
cadmium yellow	*cerulean blue*
cadmium yellow pale	*cobalt blue*
yellow ochre	*ultramarine blue*
raw sienna	*mineral violet*
raw umber	

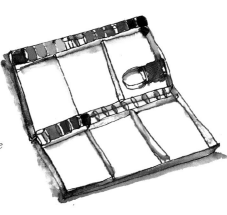

Full Palette

alizarin crimson	*burnt sienna*
cadmium red	*burnt umber*
cadmium orange	*ivory black*
cadmium yellow	*cerulean blue*
cadmium yellow pale	*cobalt blue*
cadmium lemon yellow	*ultramarine blue*
yellow ochre	*phthalo blue*
raw sienna	*mineral violet*
raw umber	*viridian (or Hooker's green dark)*

MIXING ON THE PALETTE

The less color mixing you do on the palette, the better. There's a simple sequence to follow: Dip your brush in water, give it a good shake, take a color from the wells, touch it to the mixing tray and work it just a bit, then bring the paint to your paper and let it mix itself there. Don't rely on "puddle color" as your paint supply. Instead, get into the habit of going to the paint in the wells and mixing each color afresh, then get it to the paper with as little fussing as possible. Clean your mixing surface constantly with a tissue to avoid dirty, homogenized puddle color.

As a rule you should rinse and shake your brush between colors. Sometimes I forget and dip into colors of similar value without rinsing, but no great damage is done. It's far worse to dip accidentally into a murky puddle on the palette.

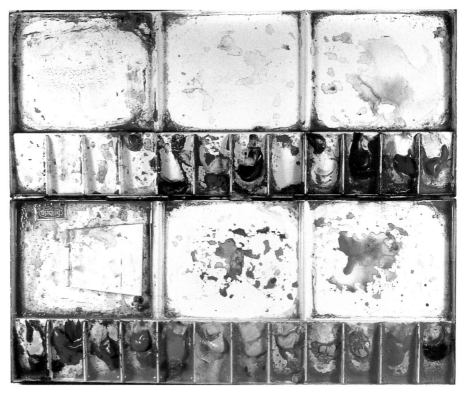

This is the way my palette looks after doing one of the figure demonstrations in this book. Notice that you can still see the individual colors; they aren't all homogenized into a gray puddle.

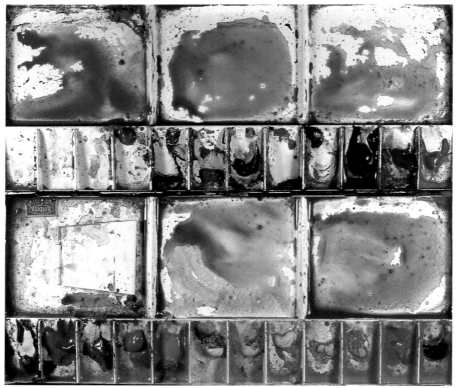

This is the way many palettes look after a painting. The color has died from too much water, too much mixing. This is a palette that ensures failure.

BRUSHES AND EASELS

All of the paintings in this book were done with round kolinsky sable brushes. Pure sable brushes are a joy but are by no means necessary. The best substitutes are made with a combination of synthetic and natural hairs (a mix that is sometimes called brown sable). These hold more water and paint than all-synthetic brushes. The various makers employ different numbering systems to indicate brush sizes, so you have to judge by the length of the bristles and the width of the hairs where they meet the ferrule (the metal part). I suggest starting with a round brush that has hairs about 1¼" long (usually a #10 or #12) and another with hairs about 1" long (a #6 or #8).

For watercolor painting I've always used a genuine French easel made by Julian (distributed by Grumbacher). It's stable, sturdy, and allows you to work at an angle or horizontally. I wouldn't bother with the kind advertised as French "style," which are usually on sale. Illustrated here is what's known as a "half easel," which is a bit lighter and easier to travel with than the regular one. The other illustration is of my friend Young Wo's easel, which is perhaps the best solution. With a photographer's tripod as a base, it's light, compact, and solid, and lets you paint at any angle.

Ideally you should have round brushes in these sizes (the higher the number, the larger the brush): a #14, a #12 or #10, and a #8 or #6.

A plant sprayer is very useful for keeping your paints moist. Never attempt to paint with dried-out paints.

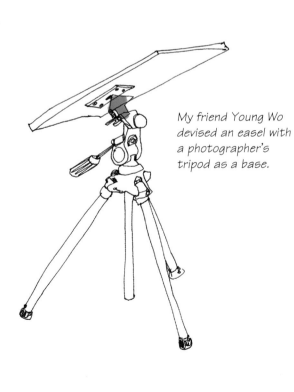

A half easel, a smaller version of a French easel, is great for traveling.

My friend Young Wo devised an easel with a photographer's tripod as a base.

BRUSHWORK

Let's move on to some exercises in brushwork. The first few drawings in this lesson illustrate some typical mistakes students make in holding and working with the brush. The rest show you correct approaches to brushwork in a variety of painting situations. I want you to practice the different hand positions and methods for applying the brush to your paper.

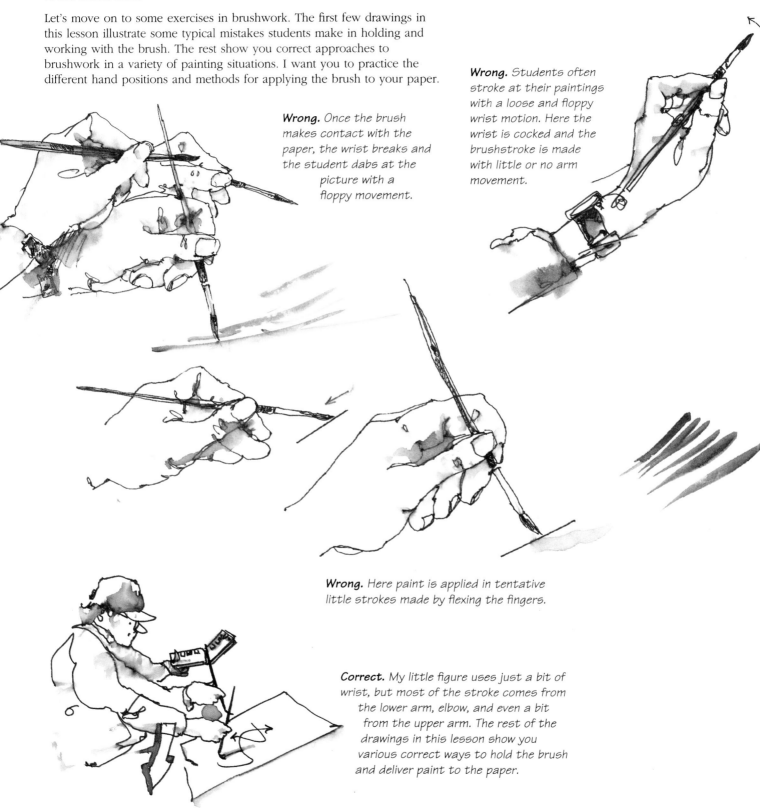

Wrong. Once the brush makes contact with the paper, the wrist breaks and the student dabs at the picture with a floppy movement.

Wrong. Students often stroke at their paintings with a loose and floppy wrist motion. Here the wrist is cocked and the brushstroke is made with little or no arm movement.

Wrong. Here paint is applied in tentative little strokes made by flexing the fingers.

Correct. My little figure uses just a bit of wrist, but most of the stroke comes from the lower arm, elbow, and even a bit from the upper arm. The rest of the drawings in this lesson show you various correct ways to hold the brush and deliver paint to the paper.

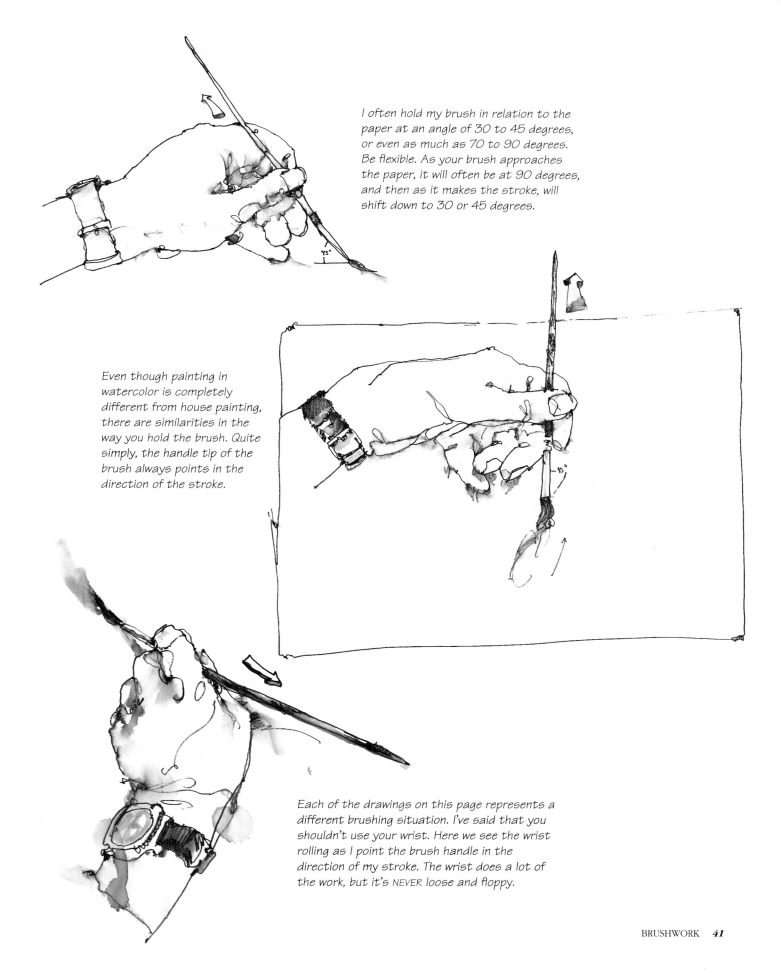

I often hold my brush in relation to the paper at an angle of 30 to 45 degrees, or even as much as 70 to 90 degrees. Be flexible. As your brush approaches the paper, it will often be at 90 degrees, and then as it makes the stroke, will shift down to 30 or 45 degrees.

Even though painting in watercolor is completely different from house painting, there are similarities in the way you hold the brush. Quite simply, the handle tip of the brush always points in the direction of the stroke.

Each of the drawings on this page represents a different brushing situation. I've said that you shouldn't use your wrist. Here we see the wrist rolling as I point the brush handle in the direction of my stroke. The wrist does a lot of the work, but it's NEVER loose and floppy.

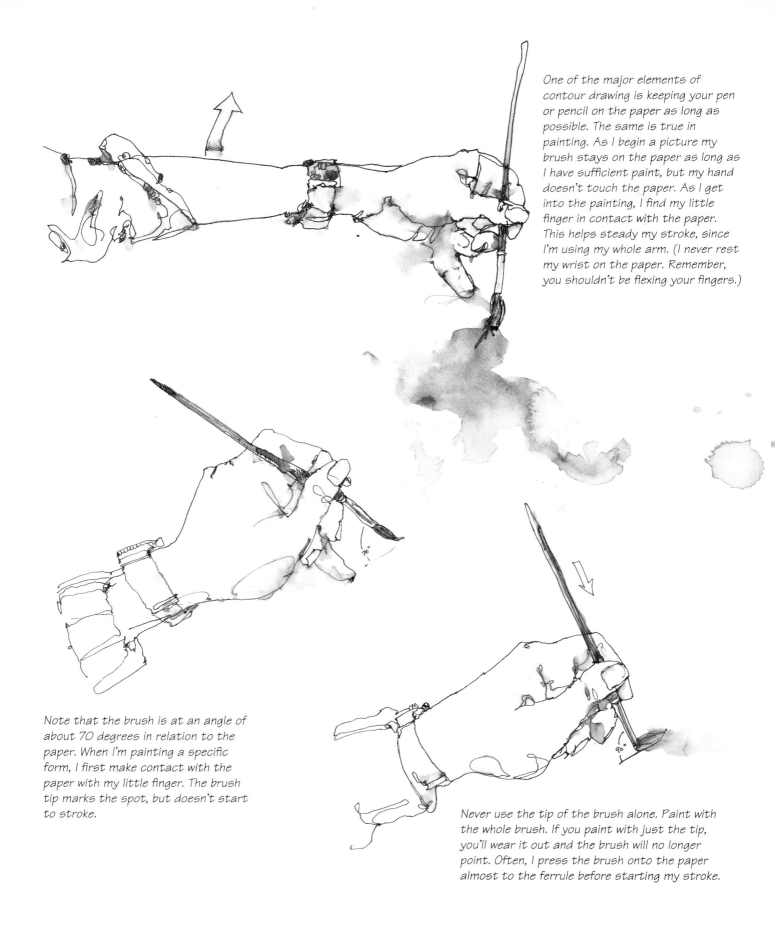

One of the major elements of contour drawing is keeping your pen or pencil on the paper as long as possible. The same is true in painting. As I begin a picture my brush stays on the paper as long as I have sufficient paint, but my hand doesn't touch the paper. As I get into the painting, I find my little finger in contact with the paper. This helps steady my stroke, since I'm using my whole arm. (I never rest my wrist on the paper. Remember, you shouldn't be flexing your fingers.)

Note that the brush is at an angle of about 70 degrees in relation to the paper. When I'm painting a specific form, I first make contact with the paper with my little finger. The brush tip marks the spot, but doesn't start to stroke.

Never use the tip of the brush alone. Paint with the whole brush. If you paint with just the tip, you'll wear it out and the brush will no longer point. Often, I press the brush onto the paper almost to the ferrule before starting my stroke.

STROKING ON PAINT

Delivering paint properly to your paper requires practice. The exercises in this lesson should help. To do them, you'll need a container of water, some ivory black, a #8 round brush, your palette, and paper. Make sure your paint is soft. If it's old and you can't stick your brush tip into it, put out a fresh dab.

In the first exercise, you will practice the basic sequence for applying paint to paper. In the second, you will practice some basic brushstroke technique.

The sequence is this:

1. Rinse your brush in water.

2. Shake the brush hard once. Don't dry it

with a tissue or it will become too dry.

3. Dip the brush into the paint.

4. Work the paint out on the palette with one or two strokes using the whole brush. Don't dab with the tip.

5. Stroke paint onto the paper using the whole brush.

Exercise 1. Following the sequence outlined above, make a trial stroke on your paper using the whole brush.

This is about the way it should look.

If yours looks like this, you didn't shake your brush after dipping it in water, or your paint is too dry.

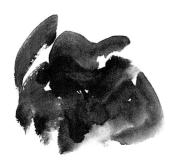

This one is okay if you're aiming for a really dark value.

A swatch that looks like this means you didn't use enough water. Maybe you shook the brush too hard or dried it on a tissue or towel, or maybe your paint is too dry.

Exercise 2. Now you'll practice painting a swatch in one fluid stroke. I painted each step of this sequence separately, but you'll actually combine the Z- and H-shaped strokes into one quick swatch. Follow the basic procedure: water, shake, pigment, palette, paper.

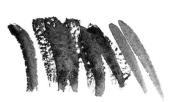

This is bad. Your brush should never work in one direction, and rarely should it be picked up between strokes.

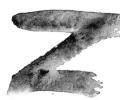

With the whole brush on the paper, make a Z using one fluid stroke, then lift.

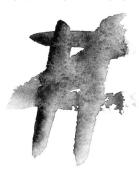

Quickly make an H on top of the Z. Try not to lift your brush as you form the H.

Now try a swatch by making Z and H strokes without lifting the brush at all.

Here's the finished swatch. It's better not to correct the paint once you've put it down. You'll learn more if you make new swatches rather than try to repair old ones.

Mixing Flesh Color on the Paper

In this lesson you'll learn how to mix colors for effective skin tones. We'll start by making some swatches with cadmium red and cadmium yellow pale, colors that work nicely for a light complexion. Instead of mixing them together on the palette, we're going to put the red and yellow next to each other and let them mix themselves, with only minimal brushing. The big problem in watercolor is getting just the right amount of water and just the right amount of paint on the brush, so practice this exercise until you get a feel for the correct ratio. Don't manhandle the paint; work it as little as you possibly can—with delicacy. Make several swatches. The idea is to see what happens when you put two (and subsequently, more) colors together and let them paint by themselves without your fussing.

Combining a red and a yellow gives you a good warm flesh color that usually needs to be cooled somewhat. To cut its intensity I use a blue, which is the complement of the near-orange you get from a red-yellow mixture. Adding a complement to any color often makes it darker, assuming you're using the same amount of water. (The more water you use, the lighter the result.) On the facing page are several swatches of flesh colors to which I've added a cooling color. These are just a few of the possibilities.

Rinse and shake your brush. Pick up some cadmium red and make a swatch on the paper. Rinse and shake your brush again, pick up some cadmium yellow pale, and make a smaller swatch of yellow next to the red.

Rinse and shake your brush, and draw the yellow along the underside of the red. Work the brush in a zigzag motion, stroking downward to make a damp area for the two colors to mix themselves. DON'T go up into the red. After you've finished the zigzag, put your brush down and watch the paint do the rest of the work on its own.

When the swatch dries, you should see a section in the middle (like the circled area in this example) that's a pretty good flesh color. Naturally, you can't have a big gob of red and yellow in your figure. Try mixing the red A BIT on the palette, dilute it some, then shake your brush and make a red swatch on the paper. Repeat the process with the yellow, still mixing the two colors on the paper instead of on the palette.

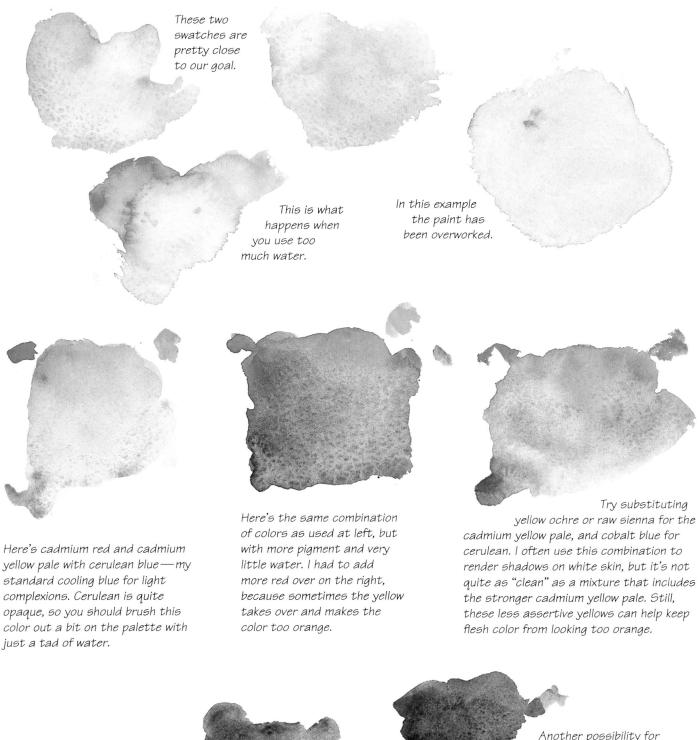

These two swatches are pretty close to our goal.

This is what happens when you use too much water.

In this example the paint has been overworked.

Here's cadmium red and cadmium yellow pale with cerulean blue—my standard cooling blue for light complexions. Cerulean is quite opaque, so you should brush this color out a bit on the palette with just a tad of water.

Here's the same combination of colors as used at left, but with more pigment and very little water. I had to add more red over on the right, because sometimes the yellow takes over and makes the color too orange.

Try substituting yellow ochre or raw sienna for the cadmium yellow pale, and cobalt blue for cerulean. I often use this combination to render shadows on white skin, but it's not quite as "clean" as a mixture that includes the stronger cadmium yellow pale. Still, these less assertive yellows can help keep flesh color from looking too orange.

This combination of alizarin crimson, raw sienna, and ultramarine blue would be good for darker complexions.

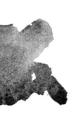

Another possibility for dark complexions is the combination of alizarin crimson, raw sienna, and Hooker's green shown here.

Dark Complexions

One of the most attractive things about a dark complexion is the color possibilities. You should concentrate on *color* in shadows and darker values and try to avoid making value changes in these areas. Shadows and darker values often act as a foundation, giving a figure its substance and form; variations of value within these darks confuse and diminish their legibility.

Think of darks as opportunities to mix rich, deep colors on the paper, with a minimum of mixing on the palette. Don't make your darks overly dense. Avoid restating them. Winslow Homer could do it, but he was Homer. Overpainted darks become dead and opaque.

Darker values should be considered dark, and intense color should stay rich regardless of the light they're exposed to, as illustrated by the striped cylinder. Light-valued and subtly colored objects show the greatest value change when exposed to strong light. There's an apparent range of shadow, halftone, and light.

Dark complexions illuminated by strong light, however, show little value difference between shadow and halftone (the area of transition between light and dark). In a dark complexion, shadow and halftone are usually the same value. Depending on the light source and the subject, there can be a dramatic value change between halftone and light. To see how this works, study the Walker Evans reference photograph shown below and follow the demonstration.

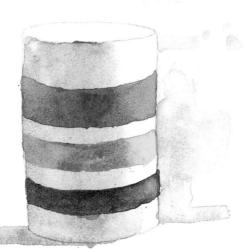

The black band changes very little in value when exposed to the light. We mustn't wash out the essence of black or of any rich, dark value. The red band must retain its redness and shouldn't become a diluted pink. Yellow is inherently light in value; here, the part of the yellow band that is out in the light should be painted with a pure yellow, such as cadmium yellow pale or cadmium lemon. For the middle value I'd try cadmium yellow, which is deeper. You really can't darken yellow without turning to green or brown. To create a dark value of yellow, I use yellow ochre or raw sienna, then raw umber or a mixed green.

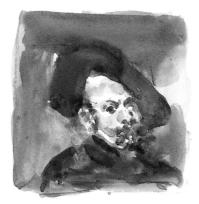

This sketch, based on a work by Velázquez, illustrates how dark values stay dark even in the light while showing strong light and shadow areas in the skin tones.

Our subject is the man at left in this photograph by Walker Evans (from Walker Evans: Photographs for the Farm Security Administration, 1935–1938, Da Capo, 1975).

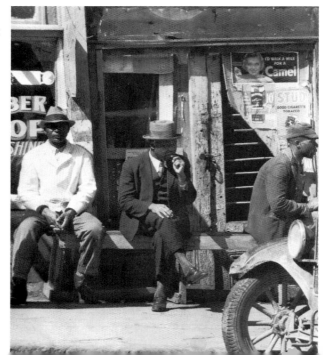

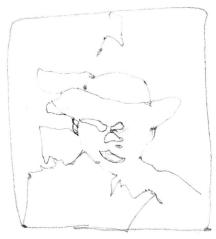

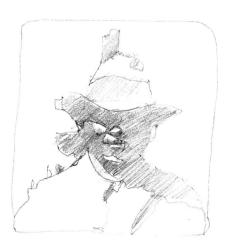

Step 1. *Draw accurate shapes of light and shadow. (Sometimes the light follows parts of features, as in the nose and mouth.) Never draw a feature or boundary you can't see when you squint; just leave it out, don't draw from your imagination. I connect adjoining negative and positive shapes of similar value, leaving out a separating line.*

Step 2. *Before starting to paint, shade in your drawing with pencil to make sure you understand the shapes of light and dark. Try for just TWO values—white paper and your shaded shape.*

Step 3. *Once you understand the shapes of light and dark, make a new drawing. Do very little mixing on the palette. Place warm and cool shapes on the paper and let them mix there. What's most important is that your darker values hold when the wash dries. Try to get them sufficiently dark the first time so you don't have to restate them.*

Step 4. *The hardest part is to retain your light shapes. If your color is too watery, you lose control. You must find the right ratio of paint to water so that the consistency is fluid but not watery. I constantly shake and dab my brush with tissue as I try to control the boundaries. This is hard. I've done these steps several times, either using too much water or making a clumsy stroke. I make a new drawing and try again.*

Step 5. *My basic flesh tone is cadmium red, cerulean or cobalt blue, and raw sienna. I used some cadmium yellow on the left underside of the hat brim (allowing some to flow into the face) and in the shadow on the shirt. I used alizarin crimson on the shirt only. Don't puzzle over what color I used where. Try for VALUE and SHAPE. I softened some edges (in the cheek and nose), but if you lose value and shape in an effort to soften, you'll miss the point. Softening edges in the right places takes practice, so forget about it until you've gotten the shapes of light and dark that describe a face.*

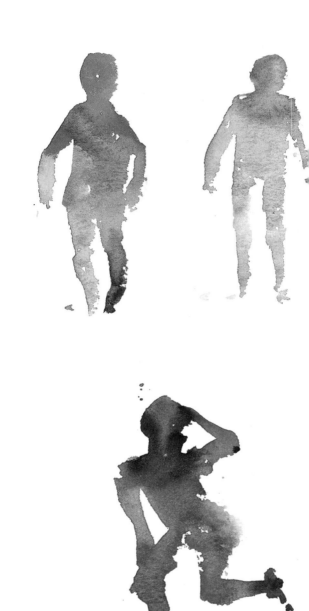

Basically you use the same hues for all skin tones: a red, a yellow, and a blue. In the vertical row of swatches at left I used cadmium red plus cadmium yellow pale, to which I then added, respectively, cerulean blue, cobalt blue, and ultramarine blue. In the row of swatches at right I simply substituted raw sienna for the yellow. It's interesting that the raw sienna and cadmium yellow pale make about the same value when each is mixed with the red. When I added the blue, things changed. The cerulean held the value in the cadmium yellow mixture, but made a darker value with raw sienna. As you move down the swatches you can see how the blue makes all the difference: The darker the blue, the darker the combination. When you get really dark, you can leave out the raw sienna and just use the ultramarine blue and cadmium red.

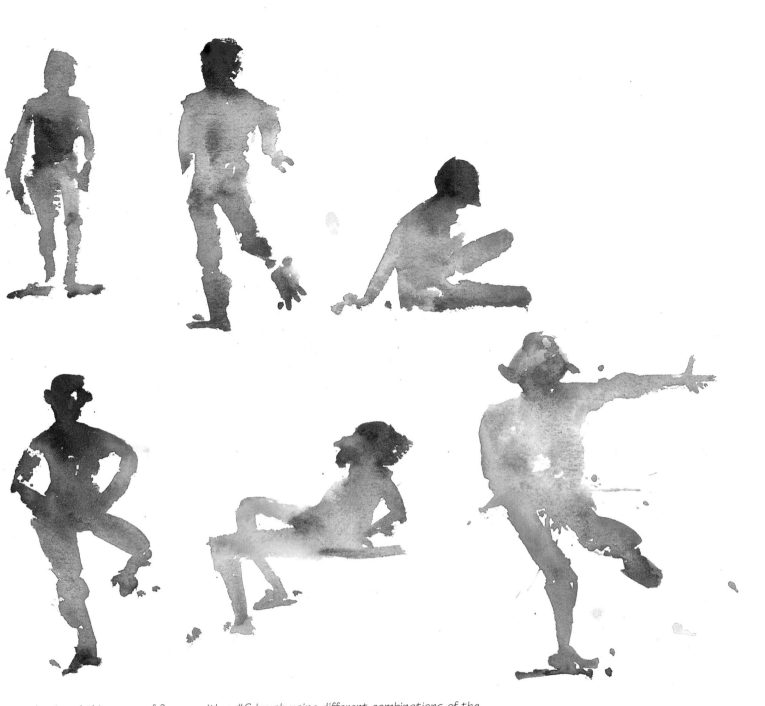

I painted this group of figures with a #6 brush using different combinations of the colors in my swatches. It's surprising that this simple palette can yield such a variety of hues and values. All of the mixing was done on the paper. Try this exercise yourself and experiment with the colors I've suggested. As you look at my figures, decide which colors I've used. Before you begin, make sure your paint is moist. I've found that half-pan cake colors make it easier to get good paint consistency for this kind of work. I like to move across the page from left to right, hoping to improve as I go. The hardest part is to avoid correcting what you've put down. A color mixing hint: The darkest darks in these examples are achieved with ultramarine blue and cadmium red—no yellow.

GESTURE PAINTING

In this lesson we'll work directly with the brush (no pencil lines) to capture movement and gesture. Concentrate less on color and more on brushwork, and on getting good shapes and a robust paint consistency. Don't plan on overwashes. Go for correct value and shape with the first try. Think of the figure as a color swatch in the shape of a person.

You'll need a #6 round brush (if this seems too large, drop down a size), watercolor paper cut into 11 x 30" pieces (I'm using Fabriano Artistico 140-lb. cold-pressed), and cadmium red, cobalt or cerulean blue, and raw sienna. For reference I'm using some sketch class work. Try copying my examples, then when you have the idea, use other figures in the book for reference. It's best to gain some confidence before actually working from life.

My gesture figures measure about 7" high in the original. It's good to start small. In the first of these two sets I used "normal" skin tones and mixed a bit on the palette, while in the second I exaggerated color and mixed mostly on the paper. In both cases I started on the left and worked toward the right, making a composition—almost a beach scene—of connected figures with varied shapes.

As you apply paint, don't dab with the tip of the brush; use the whole body to form shapes with single strokes. Make contact with the tip, then press so the ferrule almost touches the paper. If the brush is too small, you'll tend to peck and make fragmented, inaccurate shapes. The heads and arms are done with single strokes. Many of the strokes are started at the base of the form and painted up—for example, sometimes I start a new stroke at the knee and paint upward to meet the torso. Always brush in a variety of directions.

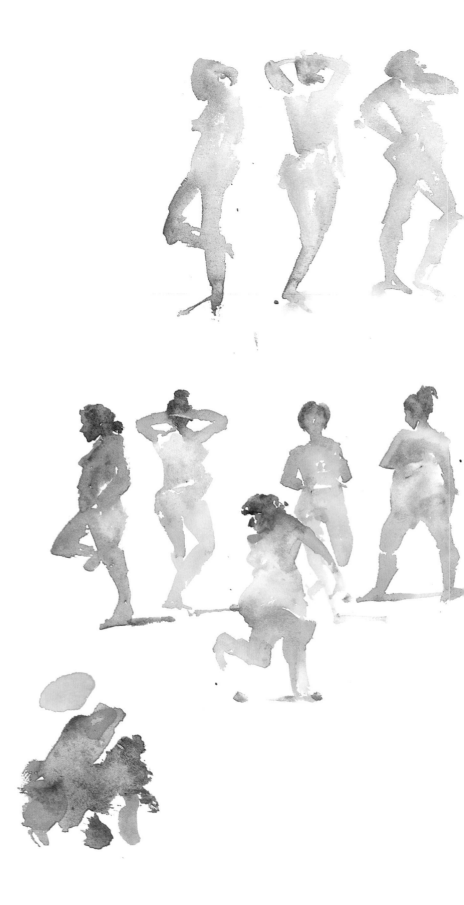

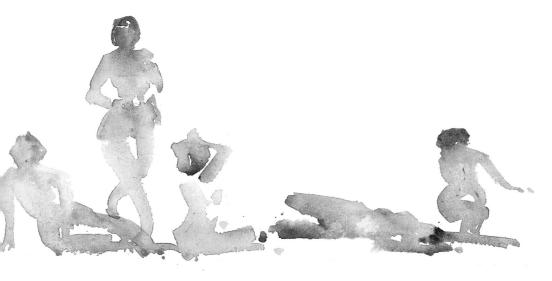

For this set of figures I mixed my colors on the palette a bit and rendered them with "normal" skin tones. There are mistakes; sometimes my brush gets too dry, leaving unwanted white specks. Don't go back to correct; finish one figure and start another. My shapes improve as I move across the page. Note how broad my strokes are, and how I've left bands of white paper to show planes of light.

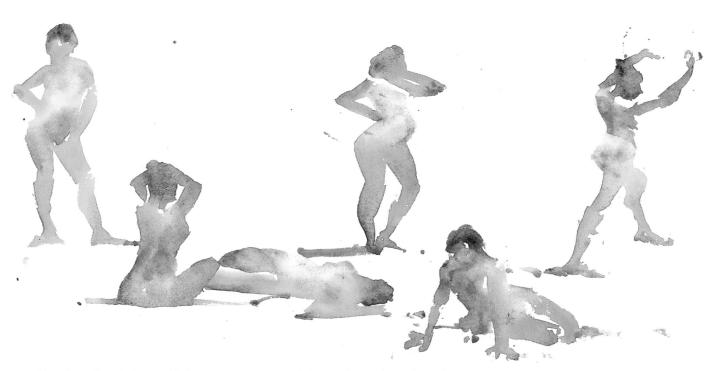

Here I used cadmium red light, raw sienna or cadmium yellow pale, and cerulean or cobalt blue (see swatch). Naturally you won't see such vibrant colors in real human skin tones, but have some courage and use your imagination. People tend to have more warmth in their legs and arms and more coolness in the torso. Here, I left less white paper and let my colors mix more by themselves, sometimes leaving blotches; in fact, my figures have a rather raw, "Technicolor" look. The figure at left has a dark complexion, which I stated using a little more blue and less water. Blue and red dominate in all of the darker figures. Even in the lighter ones where I used less blue, I used more red than yellow. (Cadmium yellow should be used sparingly; that's why I often use the weaker raw sienna or yellow ochre instead.)

COMPOSING WITH SPOTS OF COLOR

One of my favorite books on painting is *Hawthorne on Painting* (Dover), and one of my favorite terms from the book is "spots of color." To me this phrase suggests working directly, avoiding modeling, trying to get the paint on the paper with as little mixing as possible, and thinking of color as a good way to give a painting some "punch." (Many students think adding darks is the only way to pep up a painting.)

The three sketch class paintings shown here illustrate a rather exaggerated approach to painting with spots of color. Keep in mind the word "exaggerated"; to

be blunt, I went a bit overboard and the results verge on the garish. Still, I want you to see the colors I use without explaining how I choose the specific ones for each area. These are the very same colors I'd use in a more conservative mode. I'd just do a bit more mixing on the palette.

Review the lessons on color mixing, then view these three paintings as a test.

1. Find areas where I used color that I mixed a bit on the palette rather than on the paper.

2. Find places where warm and cool

colors are painted toward each other and allowed to mix themselves.

3. Find where I used single colors by themselves.

4. Find where a pure color is painted up to and softened by a still-wet, previously painted mixed color.

5. Where do I let negative surrounding shapes merge with the figure, creating a lost edge?

6. Where do I leave a hard edge between a darker negative and light positive shape?

These paintings were done in a sketch class with half-pan cake watercolors on 14 x 20" cold-pressed watercolor paper. For warm skin tones I used cadmium red and, for my yellow (I don't really think about when to use which), cadmium yellow pale, yellow ochre, or raw sienna. For cool skin tones I used cerulean and/or cobalt blue. The models' hair is raw sienna, burnt sienna, and cobalt or ultramarine blue, or burnt umber and cobalt or ultramarine. For the surroundings and chairs I used cerulean, cobalt, ultramarine, and phthalo blue, cadmium yellow, raw sienna, burnt sienna, raw umber, burnt umber, and ivory black. In all three examples, notice how I tied the models to each other with negative shapes and attached them to the picture borders with shapes or pencil lines.

PART THREE
FROM SILHOUETTE TO THREE-DIMENSIONAL FORM

PAINTING SIMPLE SILHOUETTE FIGURES

In the lessons on contour drawing we learned to keep our pencil on the paper. Here, we're going to follow the same thinking in using the brush. The idea is to concentrate on keeping the loaded brush on the paper as long as possible. Before you begin, review the section on brush handling in part two. Many students make the mistake of dabbing at the paper using only the tip of the brush.

You will need a #6 or #8 round watercolor brush (make sure it points), a palette, watercolor paper measuring 16 x 20" or 18 x 24", water, and the colors cadmium red and cadmium yellow pale (or substitutes of similar value and hue).

You will *not* use a pencil; we're going to paint without a preliminary drawing. I don't want you to think of separate parts of the figure. Instead, I want you to get used to painting connected simple shapes rather than stopping to show where one part of the figure is separated from another part.

This is my reference painting for the lesson. I like the motion of the figure. The big problem is the rather complicated arrangement of shadows, which is caused by having two light sources, one on either side of the model. You must have a good deal of practice and an understanding eye to get all of these shapes in the right places. In this and other lessons we'll simplify matters by working with a single light source.

WALKING MODEL
Winsor & Newton cold-pressed paper, 20 x 10"
(50.8 x 25.4 cm)

Here is a pencil silhouette of the figure for reference; do not use it as a preliminary drawing for this lesson.

A B

First, review the section on mixing procedure. Then mix your red and yellow. The combination should look like swatch A. You'll use slightly more of the red and a bit less of the yellow. If your mixture looks like swatch B, you're using too much water and not enough paint. Maybe your paint is old and dry. Remember: Your paint must be moist; you should be able to stick the tip of your brush into it.

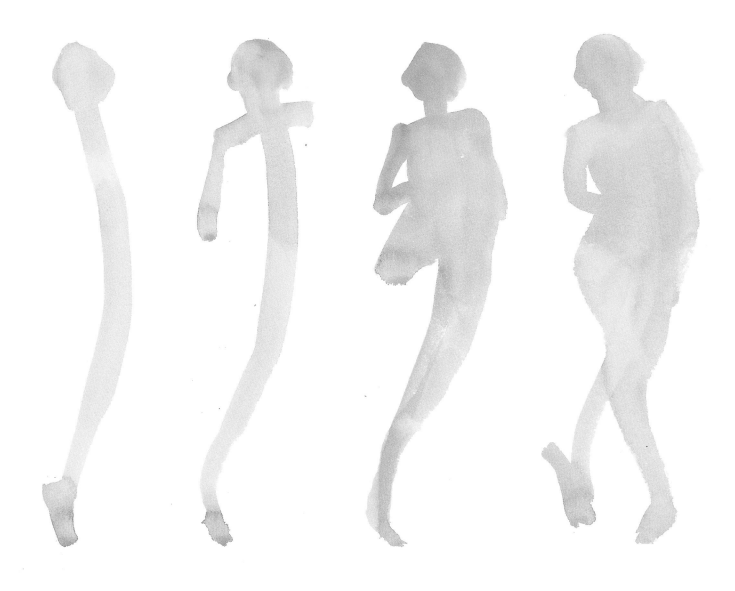

Step 1. *Charge your brush from the palette. Make an elliptical shape at the top of the page, then make a slightly curving stroke and end with a little jog suggesting a foot. YOU MUST NOT LIFT THE BRUSH FROM THE BEGINNING TO THE END OF THE STROKE. If you're having trouble, perhaps your brush is too small or you haven't mixed enough paint on the palette.*

Step 2. *Leave a gap to show the neck. Start your shoulder stroke on the right, paint across the stroke you made in step 1, then jog down to the elbow. Don't lift your brush from the paper.*

Step 3. *Continue into the lower arm and on into the torso. You'll probably have to go back to the palette to reload the brush. NEVER go back only to your water. Always add paint to the mixture on the palette as well as a bit of water. Remember the steps: Water, shake, paint supply, mixing area (palette), paper. Don't leave any holes in the torso. Paint down the right hip.*

Step 4 (finish). *Make another single stroke for the right leg. I paint down and over to the left leg to finish.*

Adding Monochrome Shadows

Now let's add shadows to a silhouette figure, this time one in a seated pose. Pretend for now that you're not painting a person, but rather the shapes of shadow. These shadow shapes will illuminate your shapes of light. If you make your shadow shapes the right size and shape and put them in the right places, a human figure will emerge.

Just as you did in the previous lesson, use cadmium red and cadmium yellow pale to paint the basic silhouette, and work with a #8 round brush for this first wash. For the shadow, switch to a mixture of cadmium red and raw sienna, and for the hair, use burnt umber.

The light is coming from behind our model, so the shadow shapes will be on the front of the face. Be aware of the direction of your light source; it'll help you remember where to place the shadows.

The finished example in this lesson is a homely piece of work, but its simplicity is the basis of figure painting. It has articulate shadows that show the shape and bulk of the figure, and definite value differences, from dark (the hair) to middle value (the shadow on the model's skin) to light (areas of the skin that are out in the light).

When working with a single-light situation like this, ask yourself the following:

1. Are you sure what's in shadow?

2. Are you always able to see shadow as opposed to middle values (halftones)?

3. Can you articulate shadow shapes and keep them in place?

Make sure you can do this exercise and say yes to these questions before going on.

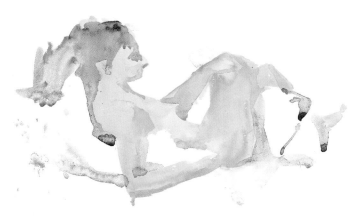

This sketch class piece is my reference for the lesson. It took me about eight minutes to paint, including the time it took for the first wash to dry before I added the shadow shapes.

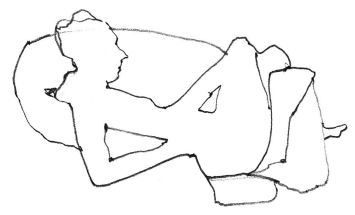

This preliminary pencil drawing is simply another reference, not part of the actual sequence.

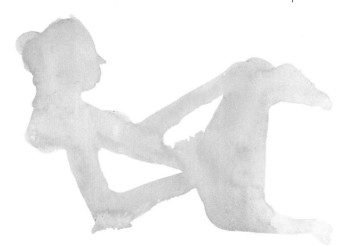

Step 1. *Wash in the silhouette just as you did in the previous lesson.*

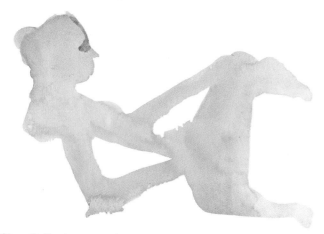

Step 2. *Don't worry about the eyes and mouth for now; they are in shadow. NEVER PAINT A FEATURE YOU CAN'T SEE. Switch to a smaller brush—a #4 or #5. Study my shadow shapes and try to copy them accurately. Start with a triangle for the eye socket and continue with a thin strip up the front of the forehead. Don't lift the brush until this shape is complete.*

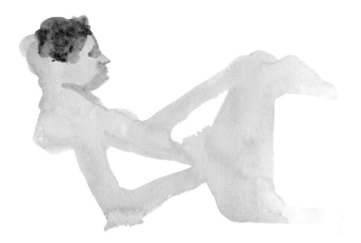 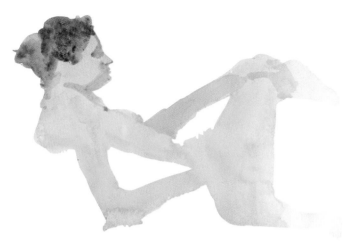

Step 3. *Paint the line under the nose and mass in the lower section of the face and chin line down to a cast shadow on the upper part of the chest. It looks ugly, but stick with me. With some rich, wet burnt umber, start massing in the hair.*

Step 4. *Block in some more hair with umber but don't fuss. Add a spot of shadow under the breast, then paint a simple, one-value shadow along the model's left forearm. We're starting to distinguish forms using shadow shapes. Now you can see the arm as it relates to the rest of the figure. I've made a couple of careful strokes to separate the hand from the knee.*

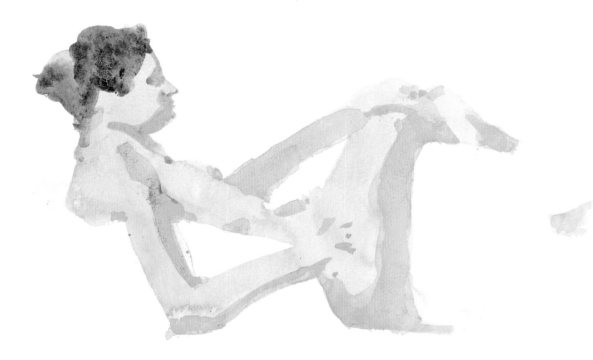

Step 5 (finish). *Single strokes show the shadow on the model's right upper arm and the one on the underside of her right forearm. When I get to the right hand, I render the fingers with small, single strokes. Then for the shadow on the thigh, I make one stroke upward to meet the left hand.*

Making Color and Value Changes

Let's turn some paint swatches into the first stage of a full-valued figure. For the basic skin color, use cadmium red and cadmium yellow pale, and cool it with cerulean (or cobalt) blue. Your mixing procedure will be a bit different here. Instead of delivering the red and yellow directly to the paper from the paint supply, work the paint out on the palette with two or three strokes. First rinse and shake your brush, then pick up some red, bring it to the mixing area, and work it out lightly. Then go to the yellow, but use just a dab; you want the red to dominate. (I often go directly to the yellow without rinsing.) When it comes time to add the cerulean or cobalt blue, you should rinse and shake your brush before picking up the blue from the paint supply. Work the blue out on a separate part of the palette with just

Step 1. Using your red and yellow mixture, start the silhouette with a head, neck, and shoulder shape.

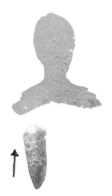

Step 2. Work your blue out on the palette and take it directly to the paper; it should be about the value you see here. Start your blue stroke down near the hip, brushing upward to meet the still-wet chest.

Step 3. Brush over along the lower section, then work down. You might have to work the blue into the warmer color a bit to combine the two areas, but avoid overworking.

Step 4. Work the cooler color down the torso with a zigzag stroke. Try not to lift your brush.

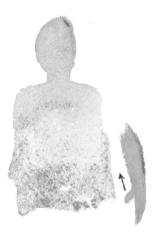

Step 5. Rinse and shake your brush, and clean your palette. Go back to your red and yellow and repeat the color mixture you made for step 1. Start your arm stroke down at the hand. Keeping the brush on the paper, paint upward toward the shoulder. It's important to vary the direction of your strokes.

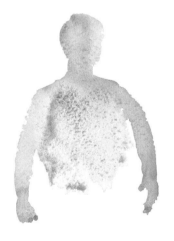

Step 6. Paint the arm into the torso. If the torso is too dry to accept the arm, don't worry; once you understand the procedure you'll be able to work faster. Repeat it for the other arm.

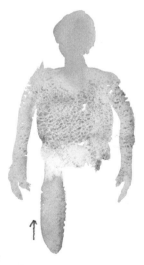

Step 7. Still using the red and yellow combination, place your brush at the knee and paint up to the cooler lower torso.

enough moisture to dilute it slightly (you shouldn't have a puddle).

Again, work with a #8 brush. Your paper and board should be at a slant of about 35 degrees from the horizontal. You're going to have to work briskly, because each section of the figure must be damp enough to accept the next addition of paint.

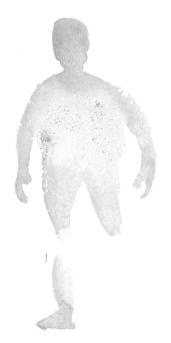

Step 8. *Repeat with the other upper leg, and then go down to the foot and paint up toward the knee. You'll probably have to recharge the brush, but try not to rely on puddle color. One of the purposes of this assignment is to learn to control color and value when mixing fresh paint.*

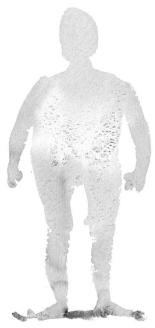

Step 9 (finish). *Paint the other foot and lower leg and add a blue cast shadow that bleeds into the foot.*

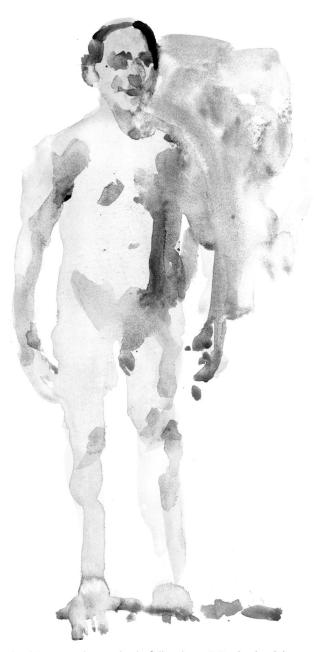

In this example, our little fellow has visited a health club and is considerably thinner. I've shown him out in the light. Notice, though, that without a darker background next to his arm and shoulder, he just doesn't make an impression. The light side seems to float, it has no substance. To make a figure project, you need dark negative background shapes to illuminate the light shapes. Always think of your darker background next to the light you're painting.

Describing Form with Shadow Shapes

Shadows don't have to be dark, but they must be simple and descriptive of the form on which they lie. In order to achieve clean, simple shadow washes, you must be able to complete fairly large areas in one effort without stopping. For this reason I avoid resistant, heavily sized papers like Arches, and find 90-lb. or 140-lb. weights the best.

In painting your shadow shape, *always* start the wash at the boundary of the shadow where it meets the light, then brush down or up and back into the shadow. This will help keep the shadow shape darkest next to the light and help you achieve a sense of reflected light within the shadow.

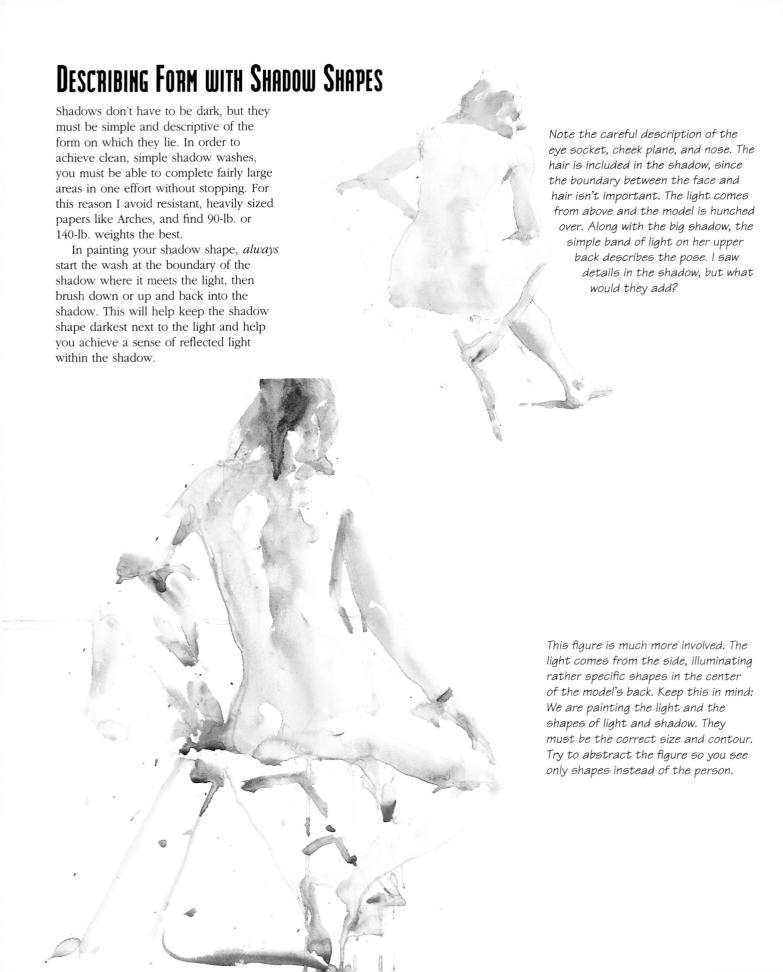

Note the careful description of the eye socket, cheek plane, and nose. The hair is included in the shadow, since the boundary between the face and hair isn't important. The light comes from above and the model is hunched over. Along with the big shadow, the simple band of light on her upper back describes the pose. I saw details in the shadow, but what would they add?

This figure is much more involved. The light comes from the side, illuminating rather specific shapes in the center of the model's back. Keep this in mind: We are painting the light and the shapes of light and shadow. They must be the correct size and contour. Try to abstract the figure so you see only shapes instead of the person.

I painted this figure using a #7 round brush and the colors cadmium red, cadmium yellow pale, cerulean blue, and, for the hair, raw sienna. I left out a first wash and started with the shadow shape. My warm and cool colors are fairly well mixed. I used some pure color—cerulean blue—at the base of the neck and in the shadow and cast shadow of the breast. I used red in the nose and in the warm overwash on the cheek; I also made the knees warm, painting them back toward the cooler hips. I started the forearms, which are warm, at the wrists and painted upward to meet the cooler color in the torso.

SEATED FIGURE
Old Dutch Aquarel cold-pressed paper, 15¾ x 19¾" (40 x 50.2 cm)

Before attempting an actual figure, practice painting some torso shapes like the ones shown here. Try for substantial, definite color and value. Here, I used just cadmium red and a smaller amount of cadmium yellow pale.

Here I started at the top with my red and yellow, and then, after working the cerulean on the palette just a bit, I added it to the back and worked it down, meeting it with more of the red and yellow. Don't mix the red, yellow, and blue all at once on the palette, as it will turn muddy.

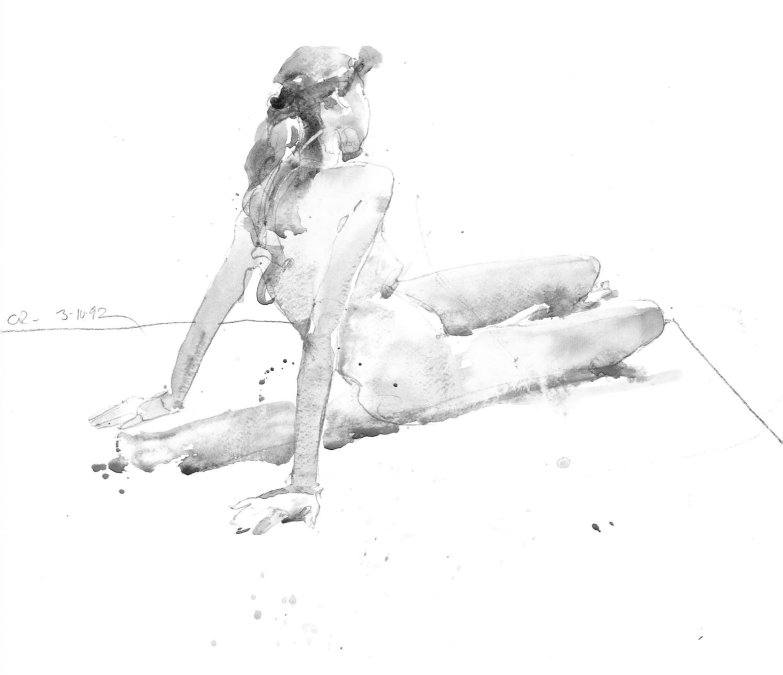

CR — 3-10-92

BLUE BOW #1
Old Dutch Aquarel 90-lb. cold-pressed paper,
15 x 19" (38.1 x 48.3 cm)

Values can be light and almost washed out, but if you simplify them and stress important hard edges—as I did here at the boundary of the model's hair and shoulders—you'll have clarity. Basically, all my edges in this painting (except for the upper back) are hard, but they don't appear overly so because they're close in value to the adjoining areas of the figure where I left the paper white. I used a warmer color and a darker value at the elbow and hand to help them project. To make the viewer look toward the head, I left the hair values somewhat darker. The back had already dried when I began to paint the hair, so to merge the two I blotted the hair lightly with tissue to lift some color. I painted the cast shadow with a single stroke of cerulean blue from the knee to the wrist. Because the skin tones were still wet, I got a merged edge.

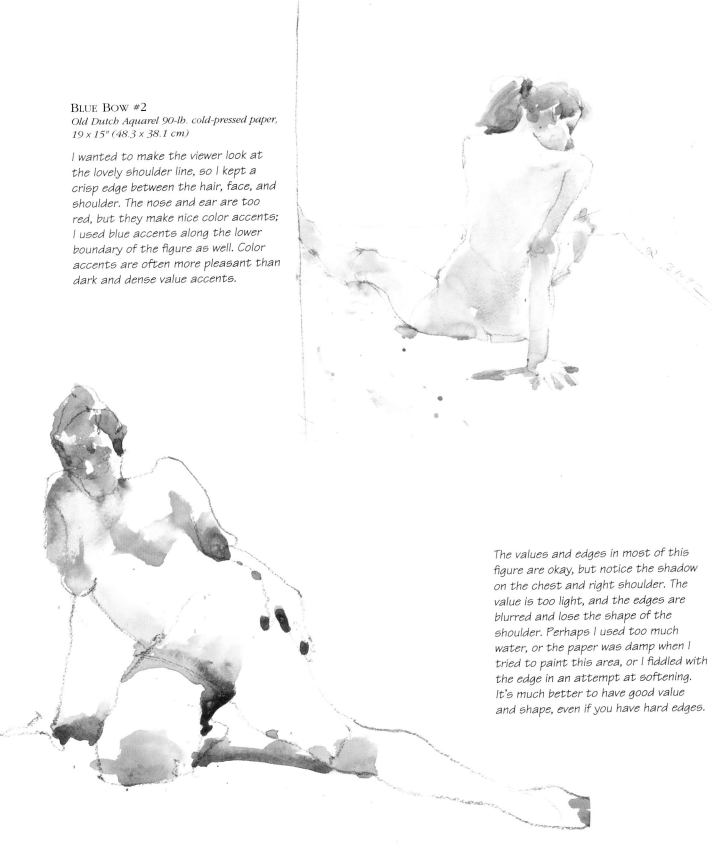

Blue Bow #2
Old Dutch Aquarel 90-lb. cold-pressed paper,
19 x 15" (48.3 x 38.1 cm)

I wanted to make the viewer look at
the lovely shoulder line, so I kept a
crisp edge between the hair, face, and
shoulder. The nose and ear are too
red, but they make nice color accents;
I used blue accents along the lower
boundary of the figure as well. Color
accents are often more pleasant than
dark and dense value accents.

The values and edges in most of this
figure are okay, but notice the shadow
on the chest and right shoulder. The
value is too light, and the edges are
blurred and lose the shape of the
shoulder. Perhaps I used too much
water, or the paper was damp when I
tried to paint this area, or I fiddled with
the edge in an attempt at softening.
It's much better to have good value
and shape, even if you have hard edges.

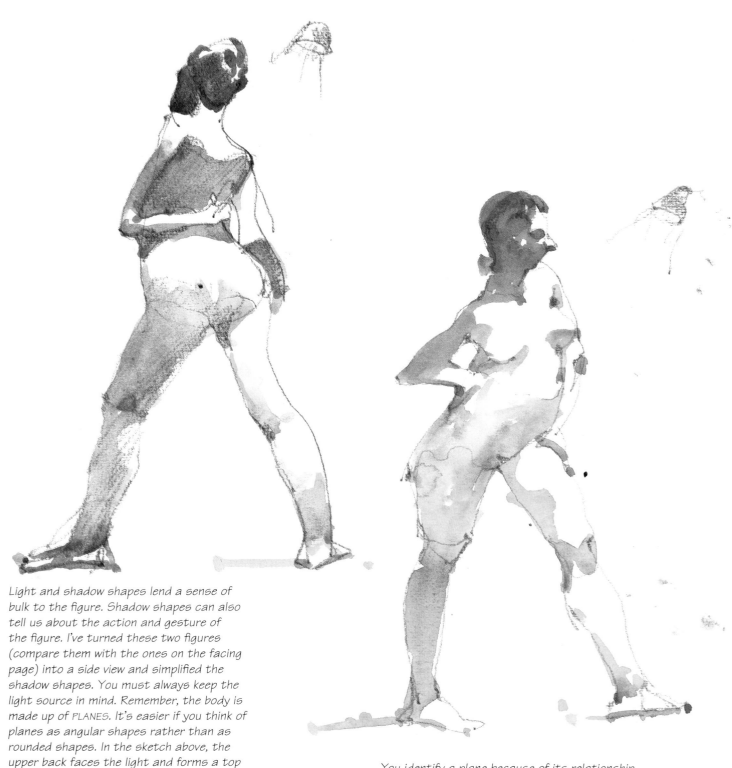

Light and shadow shapes lend a sense of bulk to the figure. Shadow shapes can also tell us about the action and gesture of the figure. I've turned these two figures (compare them with the ones on the facing page) into a side view and simplified the shadow shapes. You must always keep the light source in mind. Remember, the body is made up of PLANES. It's easier if you think of planes as angular shapes rather than as rounded shapes. In the sketch above, the upper back faces the light and forms a top plane; the lower back forms an underplane because it turns away from the light.

You identify a plane because of its relationship to the light source. In this sketch, the chest and upper part of the stomach catch the light to form a top plane, while the abdomen and right leg are in shadow and are thus underplanes.

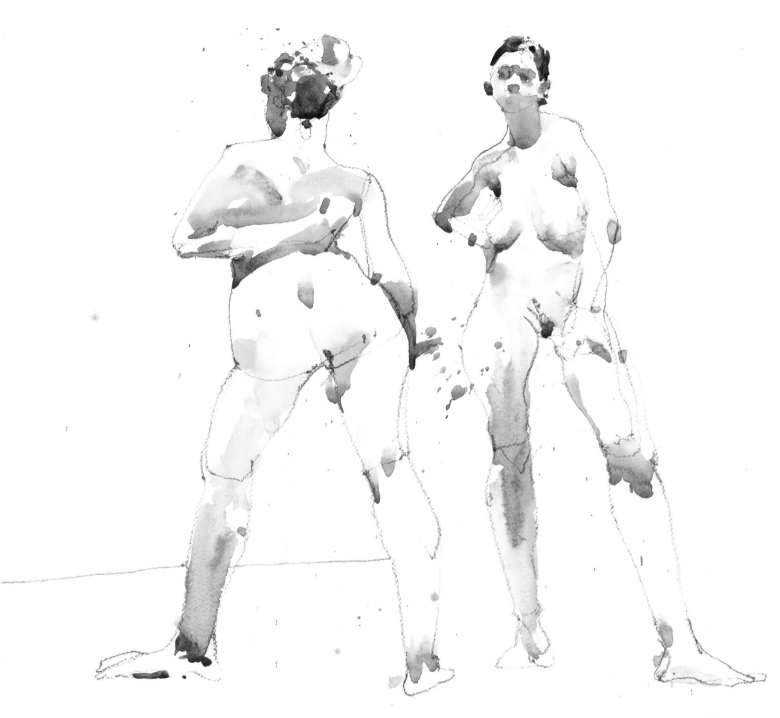

TWO STANDING FIGURES
140-lb. cold-pressed paper,
15⅝ x 19⅝" (39.7 x 49.9 cm)

The legibility of any pose depends on the direction of the light source in relation to the figure and the viewer. Sometimes the silhouette of the figure explains the gesture even without apparent light and shadow planes. In the figure at right, for instance, the shadow on the lower left leg really isn't necessary. In the figure at left, however, the shadow planes do help me. The shadow on the lower part of the face and neck suggests that the head is jutting forward, just as the shadows on the right arm and leg suggest that these forms are receding. Always understand where your main light is coming from, even if it's subtle or diffuse.

INTEGRATING CAST SHADOWS

There are two kinds of shadows: those that occur on parts of an object or figure that are turned away from the light (sometimes called "form shadows"), and cast shadows, which result when an object or figure blocks the light and prevents it from illuminating an adjacent area. Shadows on fleshy areas of the body will often appear soft, though bones near the surface of the skin may result in sharper-looking shadows; cast shadows are often hard-edged shapes. However, in spite of these distinctions, shadows and cast shadows should be painted together as a single shape rather than as two separate pieces.

Choose a nearby subject and try to identify the values you see—the relative darks and lights. Forget about color for the moment. If you squint, some of the darker values seem to merge; small variations become harder to see, and boundaries between them begin to disappear. Lighter areas also seem simpler. You don't notice as many details. Keep this rule in mind: *Squint* to lose the boundary between sections that appear to be the same value. It's necessary for any given part of a picture to relate to its neighboring forms.

In previous lessons I've emphasized that you should avoid isolating the individual physical components of your subject and concentrate instead on the separations created by light and shadow. This lesson carries the idea further by illustrating how cast shadows can be handled to integrate figures into their surroundings.

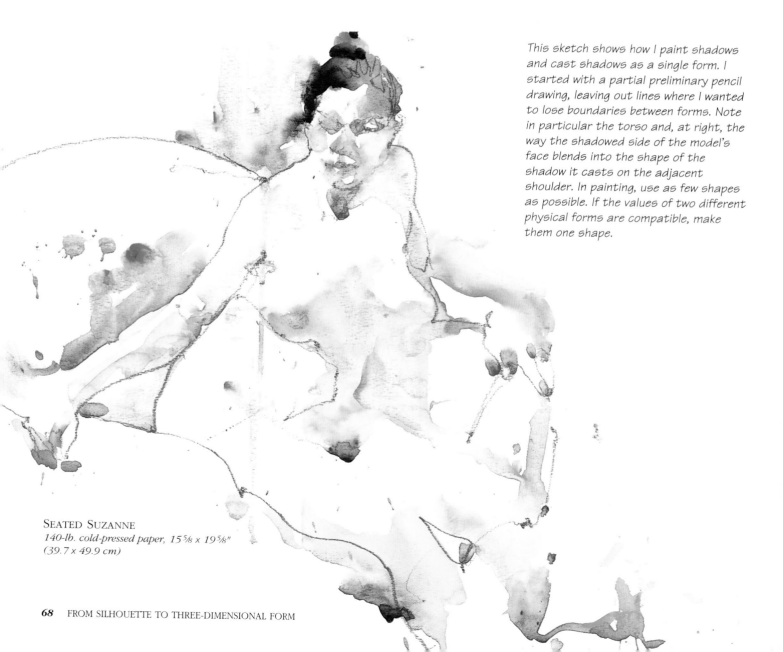

This sketch shows how I paint shadows and cast shadows as a single form. I started with a partial preliminary pencil drawing, leaving out lines where I wanted to lose boundaries between forms. Note in particular the torso and, at right, the way the shadowed side of the model's face blends into the shape of the shadow it casts on the adjacent shoulder. In painting, use as few shapes as possible. If the values of two different physical forms are compatible, make them one shape.

SEATED SUZANNE
*140-lb. cold-pressed paper, 15⅝ x 19⅝"
(39.7 x 49.9 cm)*

Here, notice in particular the hard edges, darker values, and use of pure color in the figures' elbows, backs of knees, and cast shadows. This gives the figures focus, allowing me to have some lost edges and bland areas elsewhere. Look at the model in the foreground: Do you see how I've painted the shadow on her back and the shadow it casts on the ground as a single shape? Note, too, how the shadow that starts midway down her left upper arm and continues through the elbow into the forearm merges with the forearm's cast shadow.

CHEN CHI WITH THREE WOMEN
Old Dutch Aquarel 140-lb. cold-pressed paper, 15 5/8 x 19 5/8" (39.7 x 49.9 cm)

Always paint shadows and adjoining cast shadows at the same time. In the figure at right, the elbow and its cast shadow begin a single, continuous shape that follows the length of the body and ends where the cast shadow projects past the knee. I like to tie my figures to the picture borders; here, notice how the dark shape at the left edge of the composition gradually lightens so there's an uninterrupted transition into the seated model's lower torso.

SITTING AND RECLINING FIGURES
Old Dutch Aquarel 90-lb. cold-pressed paper, 15 5/8 x 19 5/8" (39.7 x 49.9 cm)

MAKING FORMS PROJECT

Foreshortening is a means by which you can make forms appear to project or recede in space. It calls for careful observation of your subject, as well as an understanding of comparative proportions and how to manipulate them. Generally speaking, if you want to make a form come forward in space, you should make it bigger in proportion to the forms it's related to (and usually bigger than you'd think); conversely, to make a form recede, you *shorten*, or make it proportionately smaller, in the direction of depth.

Value and color can also help situate forms in space. Strong value contrasts come forward, while subtle ones recede. Likewise, warmer and darker colors appear closer to the viewer than cooler and lighter colors.

As you study the examples in the next few pages, it will become apparent that you can't paint what you see. You must digest what you see, consider what you're trying to show, and alter proportions, value, and color to illuminate the essence of your subject.

Normally the head is the first completed form that can be used as a gauge for establishing the rest of the figure's proportions. Use a pencil as a measuring device. Here, I establish my model's head size by aligning the tip of the eraser with the top of the head and placing my thumbnail at the point of the chin. With a locked elbow, I lower the pencil to compare the head size with the distance from the lower torso to the point of the knee.

Compare this pen sketch with the reclining figure in the painting below. If you concentrate on the head alone, the leg and foot will be too small. I'm not sure why this is so; perhaps it's that we perceive the head to be the most important part of the body and assume it should be bigger than the hands and feet. Keep referring back to the head as you draw the leg and foot.

SATURDAY SKETCH CLASS
*Old Dutch Aquarel 90-lb. cold-pressed paper,
15⅝ x 19⅝" (39.7 x 49.9 cm)*

Study and compare the models' proportions. The figure on the left has a foreshortened thigh; its width, including the hands, is about a head's length. The reclining model on the right has an entire leg that's foreshortened. Check the width and size of her foot and the distance from the point of the knee to the back of the thigh. Compare these measurements with the length of the model's head.

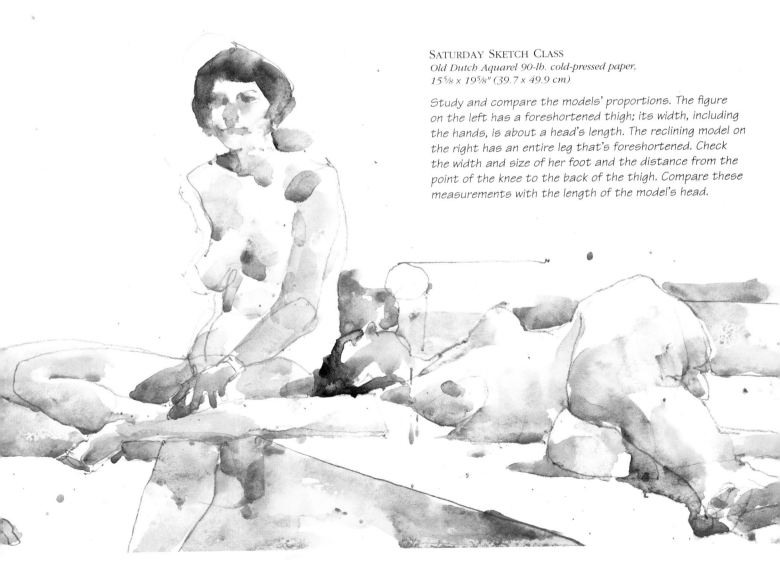

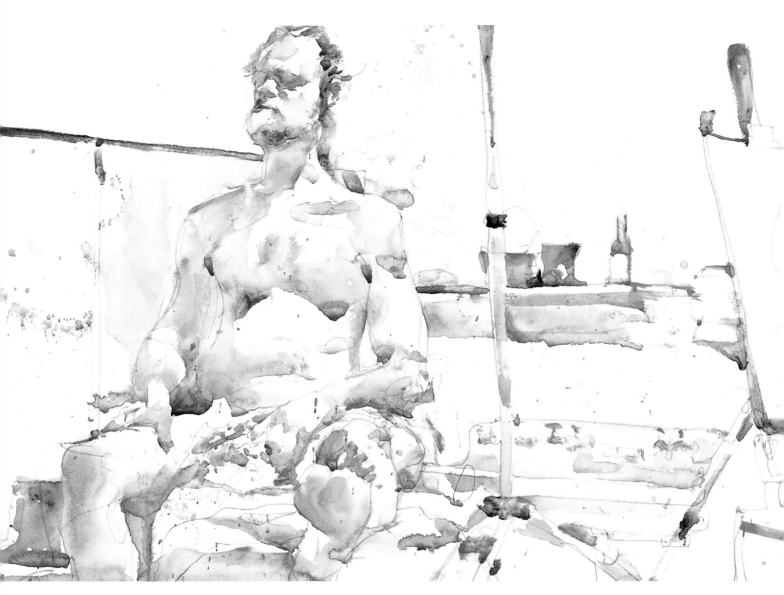

MALE MODEL
Whatman 90-lb. cold-pressed paper, 14 x 20" (35.6 x 50.8 cm)

Here's a good example of foreshortening. I was very close to the model's foot as I worked and couldn't believe just how big it appeared in relation to his head. Incidentally, there's no reason not to draw and paint the actual background in a studio even if you think the surroundings are unappealing. It's good drawing practice and much better than just doing isolated, floating figures.

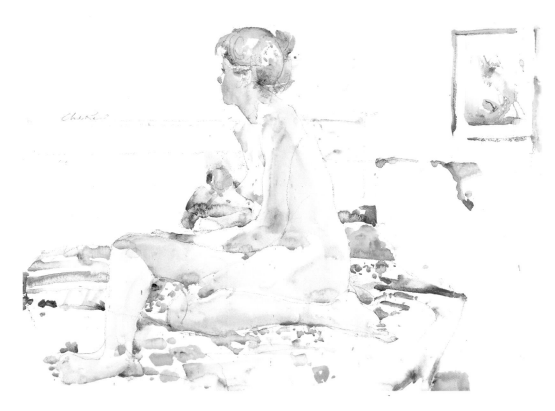

HILTON HEAD
Fabriano cold-pressed paper,
22 x 30" (55.9 x 76.2 cm)

Value can also help forms project. In this painting I made the upper part of the model's right leg darker and left the lower part light. The distinct difference between these two values suggests a horizontal plane and makes the leg seem to come toward us. To have made the values the same in both parts of the leg would have suggested a vertical plane and prevented the leg from appearing to project forward in space.

RECLINING MODEL
Whatman 90-lb. cold-pressed paper, 14 x 14" (35.6 x 35.6 cm)

This situation is similar to the one on the facing page. In the foot that comes toward us, I made an oval to get a definite form to compare with the head. A form that's meant to project must be wide enough to look convincing. Keep comparing the projecting form with the head. Edges also come into play in making forms project or recede. Here, compare the soft, "lost" edges between the model's thigh and the background with the hard edge between the lower leg and background. The harder edge makes the lower leg come forward, while the thigh recedes. Squinting helps you decide where to lose and find edges, but you must also make decisions for the sake of the picture that aren't based on what you see.

SLEEPING MODEL
Winsor & Newton 90-lb. cold-pressed paper,
14 x 20" (35.6 x 50.8 cm)

I made the cast shadow and stripe next to
the model's right breast and upper arm the
darkest values in the painting below, juxtaposing
these darks with very light skin-tone values for
maximum contrast and three-dimensional effect.
The model's left knee also comes forward because
I deliberately used a warm red-orange there. In
the "mistake sketch" shown at right, I set up
color and value contrasts in such a way that the
model's lower torso and thigh come forward
instead of the head, shoulder, and knee.

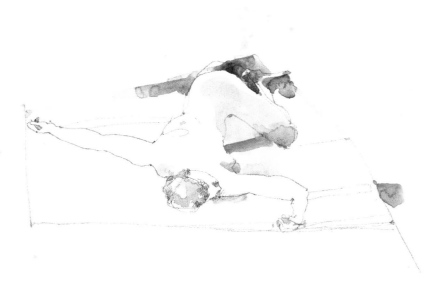

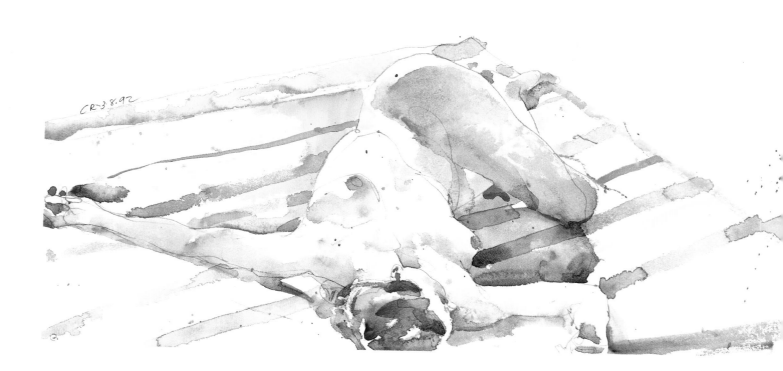

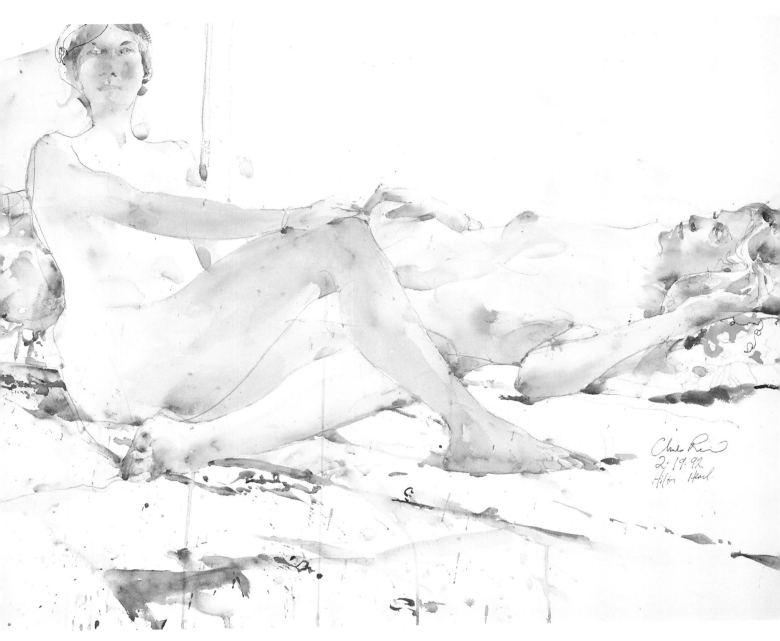

TWO MODELS, HILTON HEAD
Whatman cold-pressed paper, 22 x 30" (55.9 x 76.2 cm)

In this painting, even though the seated model's right arm and leg look to be the same color and value as the torso, some adjustment was necessary. I darkened and warmed the color of this arm and leg to make them come forward. Note especially the color and value contrast between the forearm and the illuminated part of the torso. Darker values and warmer colors appear closer to the viewer than lighter values and cooler colors.

WORKING WITH LIGHTS AND DARKS

Teaching students to see and identify shapes of light and dark can be a challenge. I guess we're trained to see features and tactile physical things. Planes of light and dark seem abstract—a word that, as a verb, can mean "to disengage the mind." Disengaging the mind is hard if you're struggling with a face or figure. A more practical definition of abstraction is that expressed by Nathan Cabot Hale, an architect and a member of the Century Association: "getting to the root of whatever is being studied." The root of painting is the ability to see, understand, and arrange shapes of light and dark in the correct places.

Let's try an experiment. I've chosen the famous Apache chief Geronimo as my subject. Working from an old photograph as a reference, I've made an adequate description of his features in a line drawing. Everything is in the right place, but how could I paint this image simply? I could try modeling the features—a daunting thought. Or, I could forget the features and instead paint the shapes of light that describe them. Make sure you get the all-important distinction between painting the actual features and painting something that *describes* the features.

If this concept isn't obvious, stop to digest it. Next, find reference photos that use two-tone depictions of faces and practice copying them. You'll start seeing and thinking in terms of *shapes* rather than features, and you'll have made a breakthrough in the art of seeing.

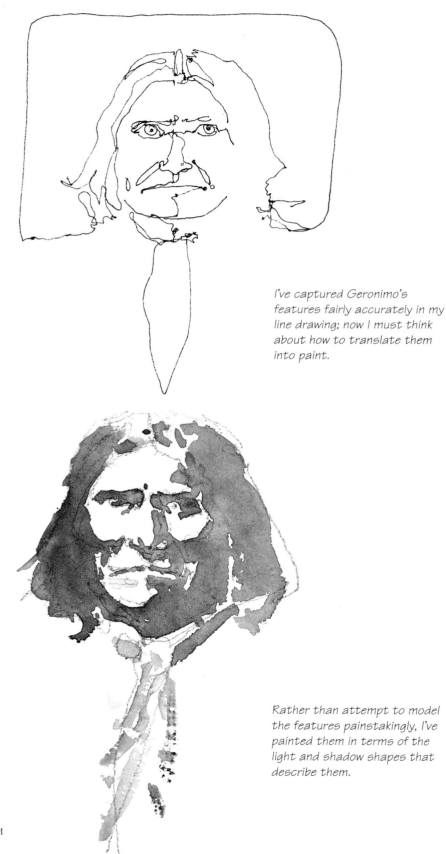

I've captured Geronimo's features fairly accurately in my line drawing; now I must think about how to translate them into paint.

Rather than attempt to model the features painstakingly, I've painted them in terms of the light and shadow shapes that describe them.

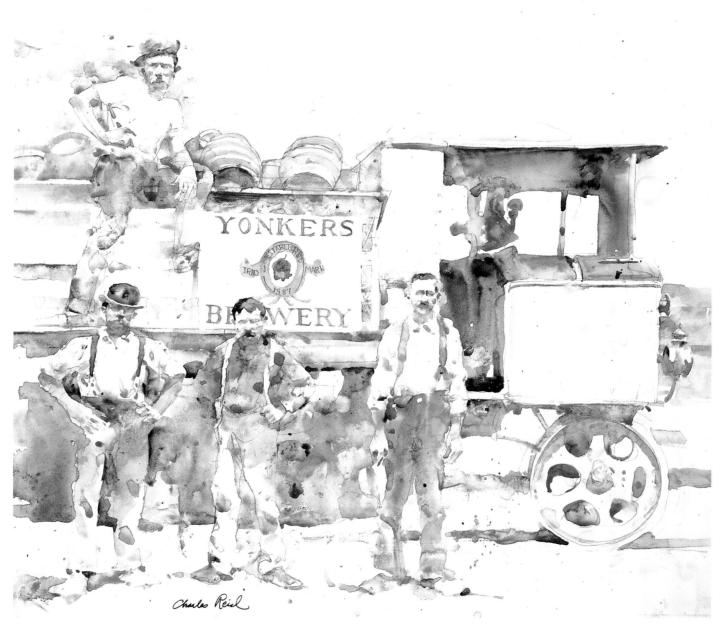

YONKERS BREWERY
Strathmore hot-pressed plate-finished paper,
22 x 18" (55.9 x 45.7 cm), courtesy Modern
Brewery Age

I especially rely on the descriptive power of shadow shapes when I'm painting the faces of figures seen from a distance. In this painting the men's heads are necessarily small, so there's not a lot of room to model their features in any detail. Think of a person's face from twenty feet away. You can't see the features, only the shapes of light and dark.

PAINTING THE LIGHT

Painting the *light* instead of painting the *thing* allows you to weave the various parts of the figure together, and the figure with his or her surroundings. It's the only way to have definition where contrasts are obvious, and at the same time avoid isolation and the "cutout" look.

Without a bit of practice it can be hard to see light and shadow shapes, so in a recent class I tried these exercises, working with a model named Susan. You'll need a #2 pencil, a sketchpad, watercolor paper, and these colors: burnt umber, cobalt blue, cadmium red, raw sienna, and cerulean blue. You'll also need a #6 round brush that points well; you'll want as big a brush as you can manage so you don't have to keep going to the paint supply. Mix enough paint so you can reload quickly.

Step 1. First, understand the position of the main light source illuminating your subject. Keep this in mind as you paint or you're bound to get so involved with small forms that you'll forget to squint and will suddenly get lost. Begin with a pencil outline of the model's head and shoulders, and lightly sketch in the hair shape to keep the face recognizable. Then draw the shapes of light, ignoring the shirt boundary and the features except where they affect these shapes. Don't imagine forms you know are there but that are hard to see within the shadow. Draw only the shapes you can see.

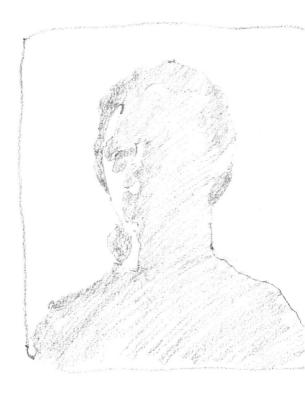

Step 2. Simply outlining the shapes of light and shadow is difficult, and the drawing, even if accurate, isn't very satisfying. Shading helps; start it in the hair shape facing the light. This forms a dark negative shape that acts as a foil for your lights. The light side of the face needs a darker shape next to it; otherwise it would be lost. If I didn't have the dark hair, I'd have to darken the background next to the lighted side of the face. This area of the head—the area of greatest contrast, where your darkest dark meets your lightest light—is known as "the effect."

Step 3. Make a new pencil drawing, but this time on watercolor paper. Using burnt umber and cobalt blue, start painting the hair on the light side of the face next to the eye. Paint UP until you come to the intersection of the forehead shadow, then stop. Next, using cadmium red and raw sienna, paint down to the edge of the shadows where they meet the lights. I finished the eye socket and cheek shadows, then went back up to the brow and down the nose, over to the upper lip and corner of the mouth, and then to the chin and neck. As you do this, try for a continuous stroke. Concentrate on getting accurate shapes and dark values.

Step 4. Add some cerulean blue to the edge of the red-sienna mixture on the palette. Incorporate just a bit of it and work the strip of center shadow color to the right, completing the shadow. Add cerulean blue to the model's right shoulder and paint rightward. You should get a blur when you reach the still-wet shadow on the neck, but don't soften edges otherwise. Add the bit of hair next to the illuminated part of the neck.

Step 5 (finish). I added a suggestion of the iris wet-in-wet. DON'T add any other washes until you're sure the first wash is dry. When it is, you could add a lighter suggestion for the hair in shadow. I wanted the hair to be darker on the light side of the face to keep the viewer's attention in the "effect" area. (I went a bit too dark in the hair at the back of the neck.) I added a light wash in the forehead and left cheek because the class wondered what would happen; I suggest you leave this step out. If you go too dark, you'll ruin your simple shadow. I also added a bit of background on the light side of the figure, because that's where I wanted the viewer's eye to go.

I had Susan change poses and used exactly the same procedure. I started with the hair above the forehead, then proceeded to the eye socket and nose. In this case, I went back to the socket and forehead and worked down the cheek to connect with the nose shadow. I added cadmium red for the part of the mouth that's out in the light, allowing it to blend with my shadow. The edges of the mouth are firm out in the light and softer— "lost"—in shadow. I used the same basic combination of colors for this painting as in the last—cadmium red, raw sienna, burnt umber, cobalt blue, and cerulean blue—but with more cerulean in the face.

For the painting of Sharon I used ivory black, mineral violet, and ultramarine blue in the hair; the skin is cadmium red, cadmium yellow pale, and cerulean blue. Sharon's pose is similar to Susan's, above, but the light is softer. Notice the shapes that describe the eye socket. NEVER let the iris overwhelm the eye socket or you'll have beady eyes. In this case I let the pupil dominate the softer iris. The shadow and cast shadow were painted as one shape. Don't let the nostril dominate by making it too dark. Notice how the mouth softens; I made the edges harder in the front and at the corner and softer on the sides, avoiding the problem of a mouth that looks like a cutout shape. Finally, notice the boundaries between light and shadow in the shirt area.

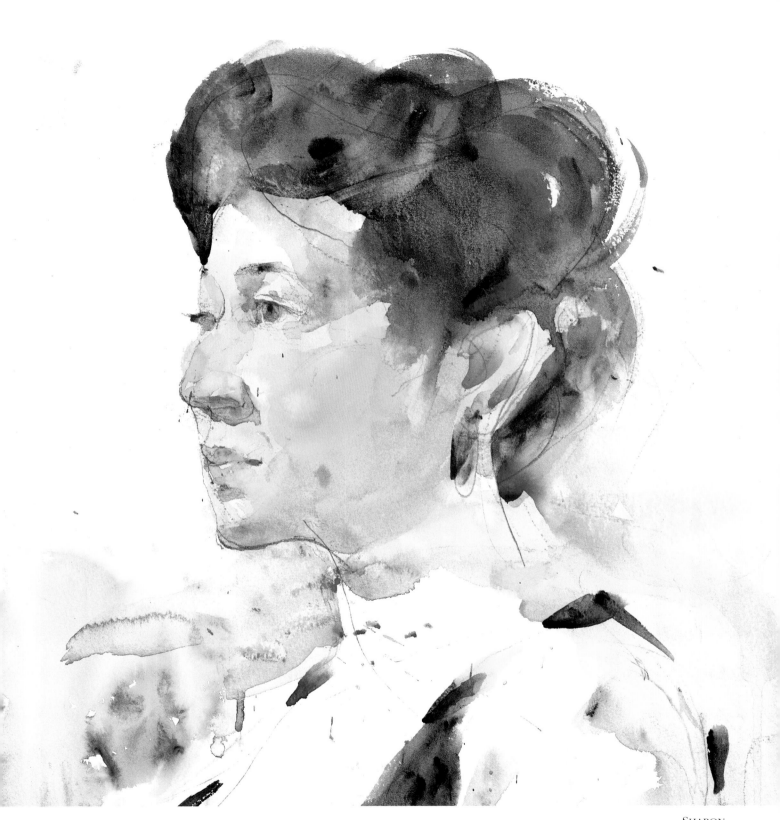

SHARON
Winsor & Newton 140-lb. cold-pressed paper, 13 x 16½" (33.0 x 41.9 cm)

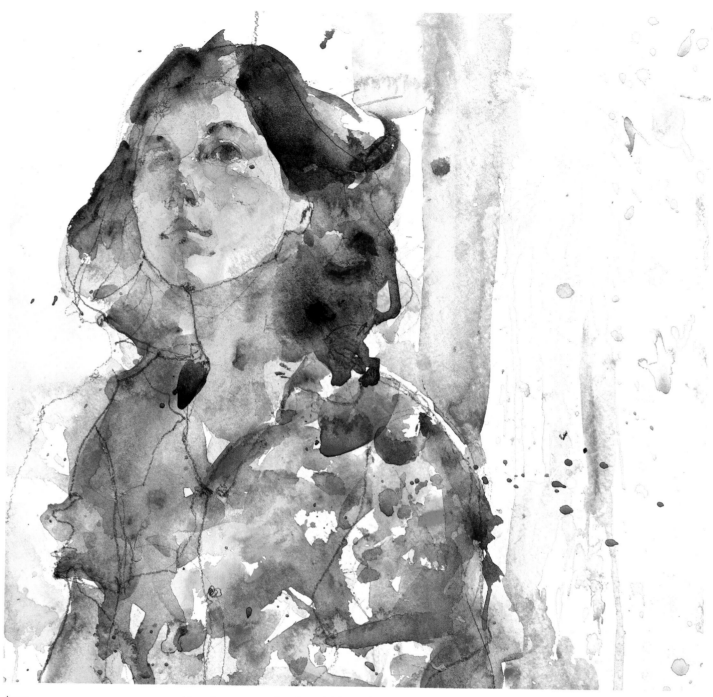

AMY
Fabriano 140-lb. rough paper,
12¾ x 13¼" (32.4 x 33.7 cm)

Here is an example of combining adjoining areas with a wash that flows across borders. Look particularly at the hair and skin tones. Where did I find separation? I tried to stress the center of the face, the nose and center of the mouth. If you see two eyes, stress the one that's out in the light, but make sure you include the inside and outside of the socket. Never paint the iris alone. Finally, I showed more of the pattern on the illuminated side of the shirt, generalizing it in the shadowed area.

RUTH IN MENDOCINO
Fabriano 140-lb. cold-pressed paper, 24 x 18" (63.5 x 45.7 cm)

I did this painting for a class to demonstrate the following: an "effect"; lightening and losing contrasts in shadow; combining two and three areas using a common value, sometimes with a color change wet-in-wet; and filling the paper with a figure to avoid difficult background decisions. Never make all boundaries of shadow shapes hard, like cutout shapes; hard edges provide stress points, giving emphasis. Here, in the face, I didn't want to stress the nose, so I softened it and allowed some shadow color to merge with it. Instead, I hardened the cast shadow under the nose and parts of the closer eye's shadow. I also used darker values in the shadows at these points to lead the eye through the figure. NEVER add these accents as an afterthought. They must be an integral part of the painting. Use a single color for accents rather than complements, and avoid black and Payne's gray.

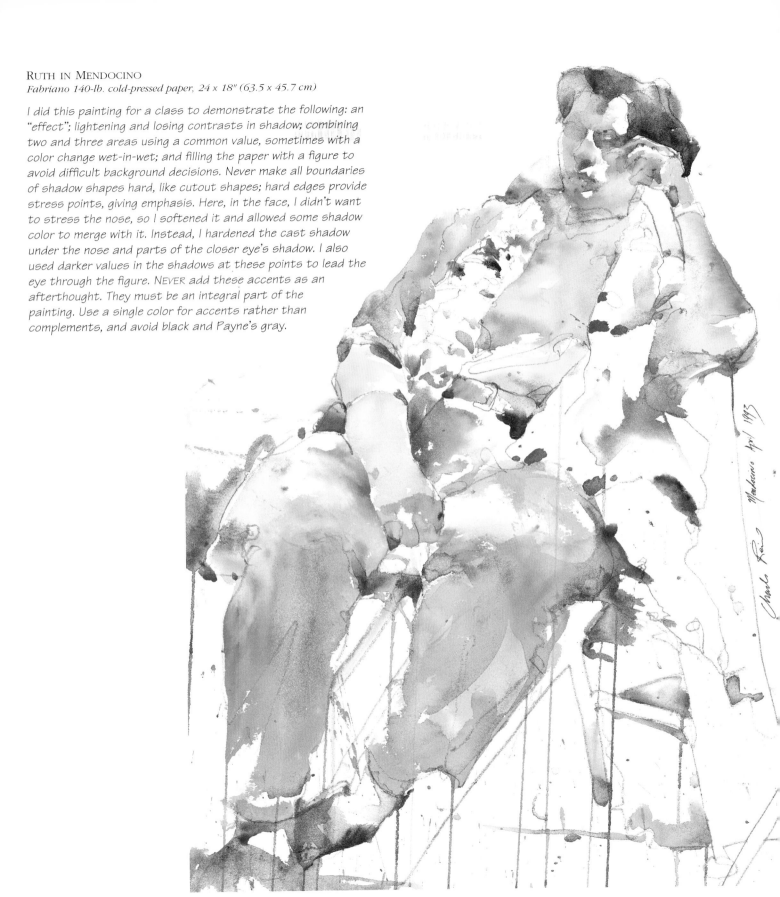

PART FOUR

FACIAL
FEATURES

UNDERSTANDING FACIAL STRUCTURE

It's natural to think of the features in linear terms; that's the way we see them, and it's the way we describe them in contour drawing, in which we depend on our eyes alone to identify and locate these particulars. Although this is a great way to begin, when it comes time to paint, we must think beyond the surface lines and understand the forms that underlie them and give the features and head their substance and dimension.

The two major structural forms to look for are the eyeball (a sphere) and the line of the teeth (a cylinder). The drawing at right shows what a face with prominent eyeball and tooth cylinder forms might look like when seen through a piece of translucent glass. Note how the eye actually extends up to the brow and down to the cheekbone, and how the tooth cylinder starts up by the nose and goes down to the chin.

The simple exercise and diagrams on the opposite page will help you gain a practical understanding of how the features relate overall to the three-dimensional form of the head.

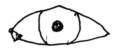

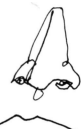

Drawing the features in linear terms doesn't account for the three-dimensional facial structures that underlie them.

In this illustration I exaggerated the spherical form of the eyeball, which sits between the brow and cheekbone, and the cylindrical form of the tooth line, which extends from the nose to the chin.

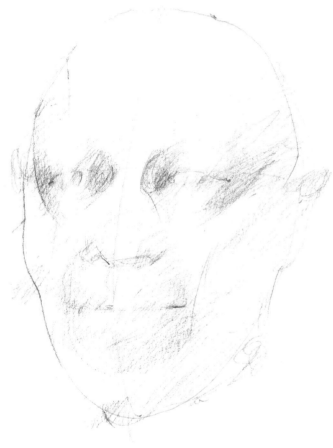

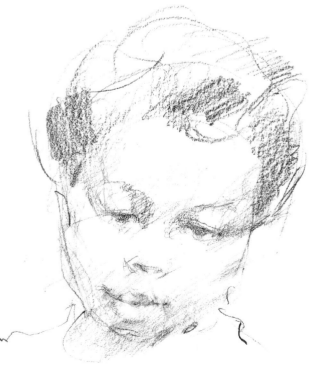

As we get older, our faces develop details—for better or worse—that tend to disguise the forms beneath the skin. It's easiest to see and understand facial structure in children.

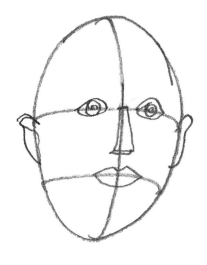

Think of the head as an egg, and draw an oval. Draw a vertical line down the center of this shape; then draw a horizontal line across the oval a third of the way from the top and another horizontal a third of the way from the bottom.

On the upper horizontal line draw a pair of eyes, leaving an eye's width between them. On the lower horizontal line draw a mouth, making sure that its center intersects with the vertical line. Next, draw a wedge shape for the nose, starting it at the upper horizontal line and extending it down to about a half or a third of an eye's width from the lower horizontal line. Finally, add ears, drawing the upper parts so they start just above the top horizontal and the bottom parts about an eye's width above the lower horizontal.

When the head is tipped back, the horizontal and vertical lines become obvious curves. The tip of the nose approaches and eventually hits the eye line.

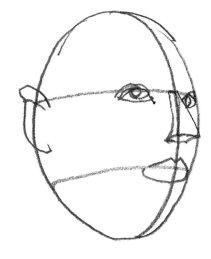

When the head is tipped forward, the point of the nose hits and overlaps the mouth line. Notice that the ears ALWAYS keep their position in relation to the curving eye and mouth lines.

The eyes ALWAYS stay an eye's width apart. When the head is turned to the side, the bridge of the nose overlaps the far eye, making it necessary to estimate the distance between the eyes.

Gauging Feature Placement Accurately

When I'm working from a model, I often find myself using my knowledge and preconceptions to make my drawing. I'm not really seeing the model; I'm using tricks and clichés, drawing from my head instead of from the model. Have you had this experience? Well, let's make a deal: From now on, we'll really *look at* and understand our subject and truly draw what we're seeing.

Here's an example of a poor translation. The artist is confused by a difficult arrangement of features and unconsciously turns to memory for information. He brings the head down to eye level and turns the face into a front view. This shouldn't happen if the artist is using the right side of his brain to make his contour drawing. But when you get tired, it's easy to click over to the left side of your brain and resort to memory.

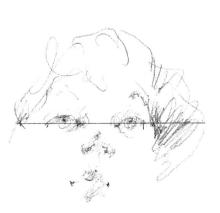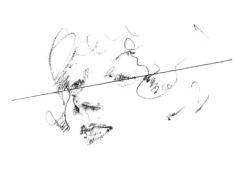

When you are looking up at the face, always check the relationship of the nose tip to the eye line, as in these three drawings.

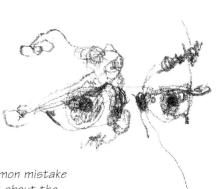

A very common mistake is to forget about the eye socket and make the eyes too close together, as I've done here.

In a three-quarter view, look for the triangular negative shapes formed by the nose and cheek line. This is a good check even if you think you know where the nose is in relation to the cheek.

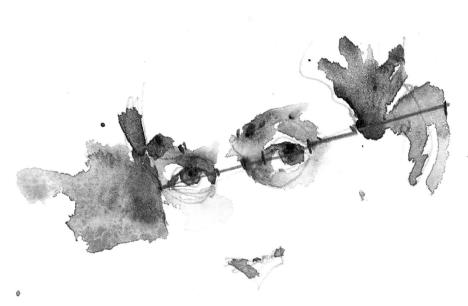

Always check the relative spaces between the features. Here, I used a line as a ruler of sorts to measure these spaces, stopping to make dots wherever I needed to establish comparative distances. I started on the far side of the face, moving through the features until I reached the ear boundary on the near side of the face.

EYES

Despite the multitude of eye types, there are only a few general thoughts we need to keep in mind when rendering them. For example, no two eyes in any given pair are identical—not even in the same person, and not even in a front view. As drawing A, below, illustrates, generally in the front view the top lid is more angular, while the bottom lid is gently curved. Always remember: Nature never repeats herself.

In rendering the eye, *never* draw just the lids, leaving out the iris, as in drawing B. It's good practice to follow a sequence like the one in drawing C: Start with the upper lid, draw down and around the iris and pupil, then go back up and around, completing the whole eye, socket, and eyebrow as one thought. Keep in mind that the iris and lids change shape according to your angle of view.

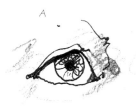
A

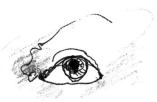

B

C

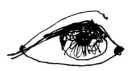
D

The upper edge of the iris is overlapped by the upper lid. The lower edge of the iris sits on or slightly above the lower lid.

E

When painting the eye, make the upper lid darker. I usually stress the upper lid with a liner stroke and show the lower one with a subtler indication of the eyeball, leaving the rim of the lower lid untouched.

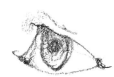

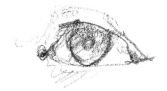

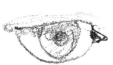

The iris and the eyelids change shape depending on your point of view.

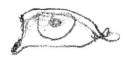

Let's paint an eye. Draw the upper lid and iris, making sure the upper lid overlaps the iris. Keep your pencil on the paper as you do this. Note that I've pressed harder with the pencil in the upper lid and iris, then eased off.

To paint, start with a warm color for the upper lid, such as burnt sienna. Blue upper lids can look harsh.

When you get to the iris, switch to cobalt blue. If your brush is too dry, rinse and shake it. You want a blend as the blue of the iris meets the warm upper lid. Notice that the iris is quite dark at this point.

Finish the upper lid down to the inside corner, leaving parts of the upper lid untouched as you work up and around to show the flap of skin around the eye. Connect the eye with the socket, keeping a hard edge above the eye but softening as you make the transition up to the skull above the eyeball. I used cerulean blue, cadmium red, and raw sienna as I painted out into the socket.

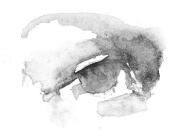

It's important to get a deep, rich but not opaque dark for the inside of the socket. I used cadmium red, raw sienna, Hooker's green (or cobalt blue) and cerulean blue. The darker socket section has just the red, sienna, and green. In the lighter section I dropped the green and used the blue. Try for a "watery" look, allowing some blends but including some definite separations.

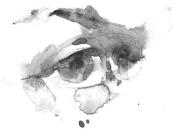

Add the pupil: try ultramarine blue or ivory black for this. The iris should be a bit damp so you get some blur. The pupil should be the only real dark you add. I often add a color accent for definition; notice the spot of red in the upper lid.

To review: The eyes are always an eye's width apart.

In an extreme three-quarter view, there is an eye's width from the inside corner of the eye to the bridge of the nose.

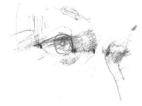

It's easier to understand the eye socket if there is a definite shadow.

NOSES

In drawing the nose, always start with the underplanes of the nose tip. These planes give the nose structure and make it project. As a beginning rule (one that can be broken later), make the values in the tip of the nose as dark as the nostril. If you make the nostrils dominate, you'll get the "pig" look. Stress the darks on either side of the nose up in the eye socket area and in the underplanes of the nose. Do *not* stress the side planes of the nose, as doing this will flatten the form and isolate the nose from the face.

Practice drawing a few noses at different angles before you attempt them in paint. When you do switch to paint, the trick is to control your values; you also have to take care when softening forms not to lose the accuracy of your shapes.

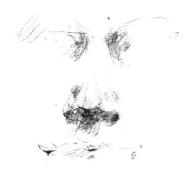
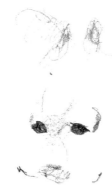

To establish structure and dimension when drawing the nose, always start with the underplanes of the tip.

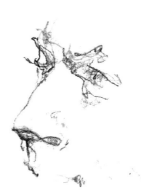

To avoid the "pig" look, make the values of the nose tip as dark as the nostrils. After you've gained some experience you can veer away from this rule.

Don't flatten and isolate the nose by stressing the side planes, as here; instead, emphasize the darks on either side of the bridge and in the underplanes.

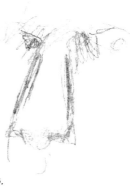

Try to draw and paint the underplane of the nose tip and the nostril as a single thought. At right, I drew these two forms with a sideways figure eight.

1 2 3 4 5 6

Let's practice painting the nose. Make a scale of six values. Using cadmium red, yellow ochre (or raw sienna), and a touch of cerulean blue, I start with my darkest flesh-tone value at left and get progressively lighter. When I get to value 4, I substitute cadmium yellow pale for the yellow ochre because it makes a fresher skin tone in the lighter values. If you're a beginner, skip the blue and just work with the red-yellow combination.

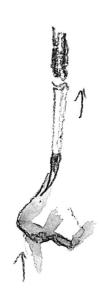

Step 1. Mix a value that approximates my value 2 on the opposite page. You want it fairly dark, since it will dry lighter, but you're also going to use it to make your halftone. Paint the underplane of the nose and the shadow shapes on either side of the bridge. Concentrate on getting good shape and value at this stage. If the value is too watery or too light, add more red and ochre, and maybe some blue straight from the palette. Don't add any more water.

Step 2. Rinse and shake your brush. While your shadow shapes are still wet, hold the brush at a 30-degree angle to the paper and paint upward, pulling color from the shadow shape out and up and painting around those areas you wish to remain light. With the brush still at the same angle, go down to the upper lip and paint up to the nose tip. You're making a damp path to release the nose tip color. Here, I didn't have a dark enough value or the shadow shape was too wet, so my example looks washed out.

Step 3 (finish). The finish is a bit better in terms of value. The idea is to do the softening procedure in just one step. We want a combination of hard and soft, lost and found edges.

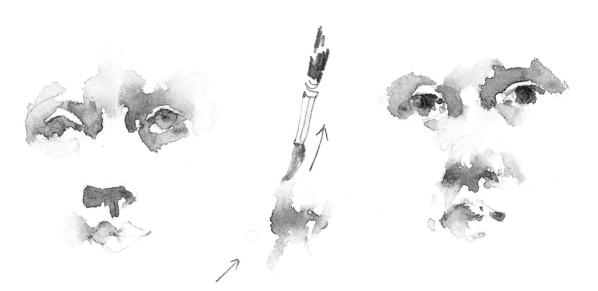

Here's the same approach in a female head. In the sketch at the far left, the value is dark enough, but I fudged the shape under the nose. The color is too red in the sketch at near left, but that's okay; I've been able to keep a fair shape with decent value and edge variety.

MOUTHS

Underlying the mouth is the line of the teeth, which is cylindrical in form. Certainly we know this, but it's easy to forget, since the mouth often looks hard and flat. It could be lighting, or perhaps the model is wearing dark lipstick; or maybe the mouth is thin and linear, just a mark across the face. Still, you should render the mouth so that its structure reflects the rounded form it sits on; the lips should appear to go around this form. Think of the mouth as an important feature, but one that is less important than the overall structure of the face. The eyes, nose, and mouth give the face its character, but they can't float; they need a foundation.

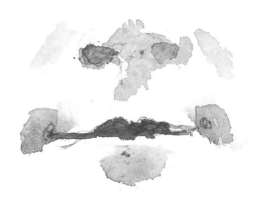

In the painted example, I made the mouth too definite, too dark, too flat. It looks isolated. In the drawing, I concentrated a bit too much on the line separating the lips.

This exercise should help. Draw a cylinder. Make the darkest part about a quarter of the way in on the shadow side, then lighten up a bit to suggest reflected light. Now draw a mouth in the middle of the cylinder. Just do a line drawing. This example is very simplified, but you should be able to see the principle at work. The lines of the mouth are automatically incorporated and disappear in the shadow. This mouth has form.

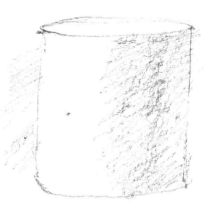

Each of these mouths is different, but they all have two things in common. First, in the lesson on eyes we saw that the top lid is more angular, the lower lid more curved. The same is almost always true of the lips. Second, there is usually a break in the upper lip near the corners of the mouth, sometimes on the upper side, sometimes on the lower, sometimes on both. In these drawings I've marked these breaks with dots.

Always stress the corner of the mouth that faces the light. I let this corner merge with the form heading up toward the nose. Next, soften and lighten to help suggest the roundness of the cylindrical tooth line, then darken the mouth in the center to make it project forward. As the mouth goes into shadow, it becomes part of the shadow and is no longer a separate form but part of the larger form of the lower face. Just a suggestion of the corner of the mouth in shadow tells us all we need to know.

Start painting the mouth with separate strokes, almost as if you were working in Morse code. Then rinse and shake your brush, and soften and connect the various strokes as I've tried to illustrate here. Always stroke diagonally across a form. Think in terms of making single strokes; never dab and fuss.

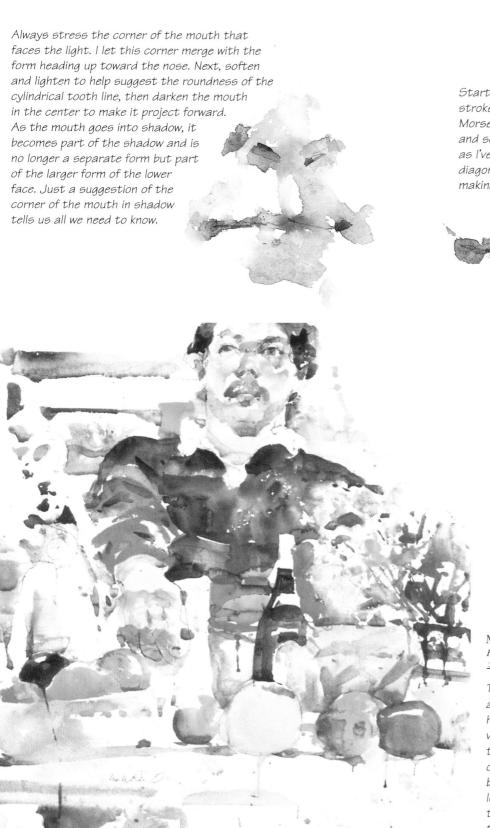

MIXED BAG
Fabriano cold-pressed paper,
22 x 22" (55.9 x 55.9 cm)

This figure's mouth looks anything but flat and isolated; his rather full lips have definite volume, which is emphasized by the dark spots of color I placed on either side of the form and by the shadow just under the lower lip. Here is a case where the upper lip is more rounded than angular.

PART FIVE
FIGURE PAINTING
DEMONSTRATIONS

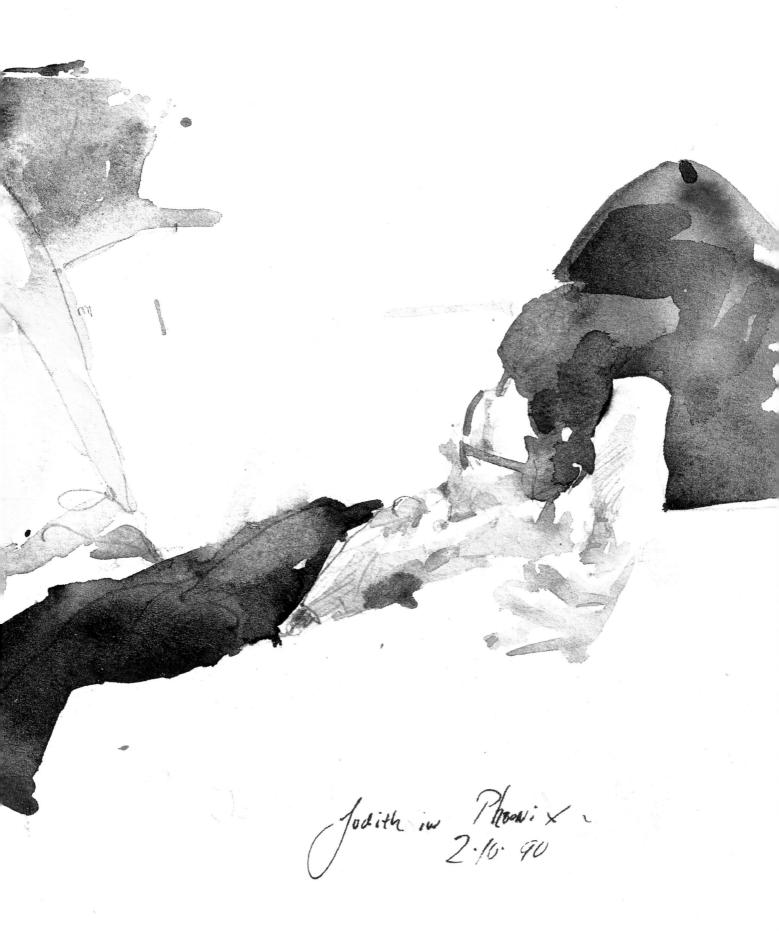

Judith in Phoenix
2·16·90

CAPTURING THE MODEL'S POSE

When working from the model, you have to pay attention to what is actually happening in the pose rather than assume that you know. As we saw earlier, one of the pitfalls here is the tendency to "normalize" a pose, to make it more "regular" and thus perhaps easier to record. But doing this robs the model and pose of all character. To grab and hold the viewer's interest, a figure painting or drawing must have an element of tension that can convey a palpable mood and human presence. This may be in the tilt of a head, the graceful gesture of an arm, or the thrust of a leg, or in the play between shadow and light or some other dynamic.

Painting accurate figures is one thing; infusing them with life is quite another. Conveying the spirit of your subject is more important than getting all of the anatomical details right. With that in mind, before embarking on the figure painting demonstrations, let's study some of the basics involved in interpreting and capturing the model's character and pose.

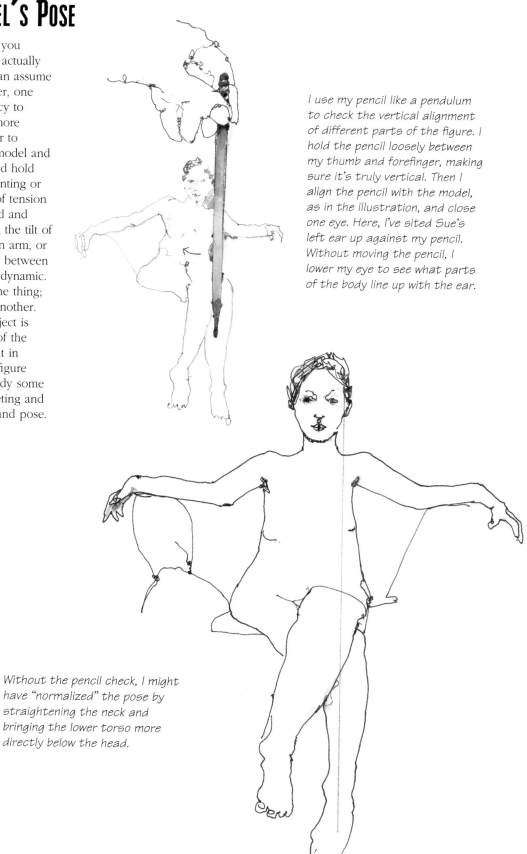

I use my pencil like a pendulum to check the vertical alignment of different parts of the figure. I hold the pencil loosely between my thumb and forefinger, making sure it's truly vertical. Then I align the pencil with the model, as in the illustration, and close one eye. Here, I've sited Sue's left ear up against my pencil. Without moving the pencil, I lower my eye to see what parts of the body line up with the ear.

Without the pencil check, I might have "normalized" the pose by straightening the neck and bringing the lower torso more directly below the head.

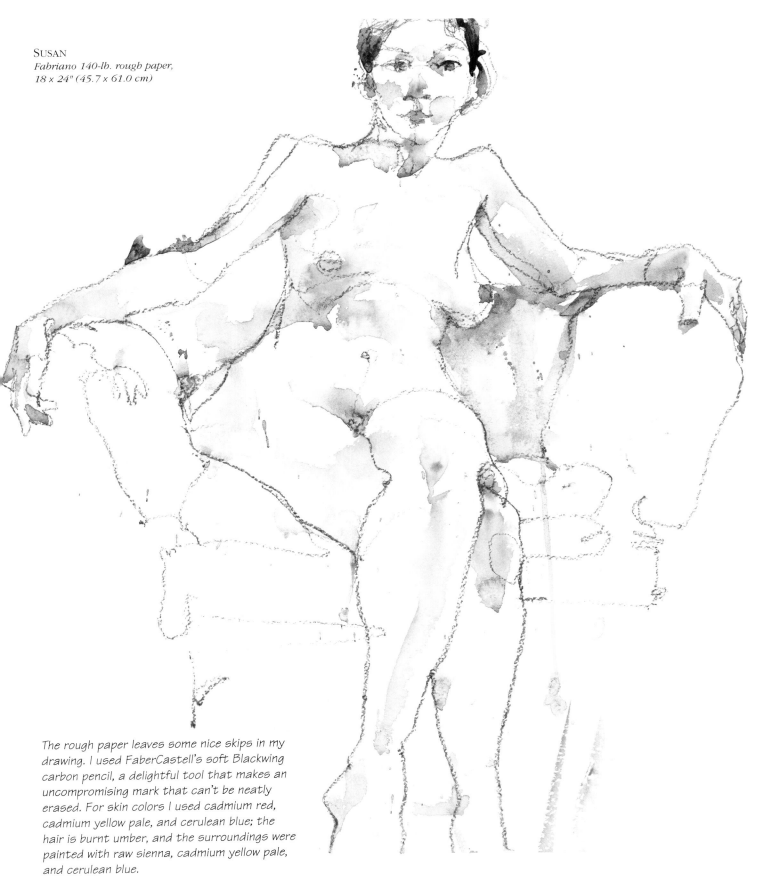

SUSAN
*Fabriano 140-lb. rough paper,
18 x 24" (45.7 x 61.0 cm)*

The rough paper leaves some nice skips in my
drawing. I used FaberCastell's soft Blackwing
carbon pencil, a delightful tool that makes an
uncompromising mark that can't be neatly
erased. For skin colors I used cadmium red,
cadmium yellow pale, and cerulean blue; the
hair is burnt umber, and the surroundings were
painted with raw sienna, cadmium yellow pale,
and cerulean blue.

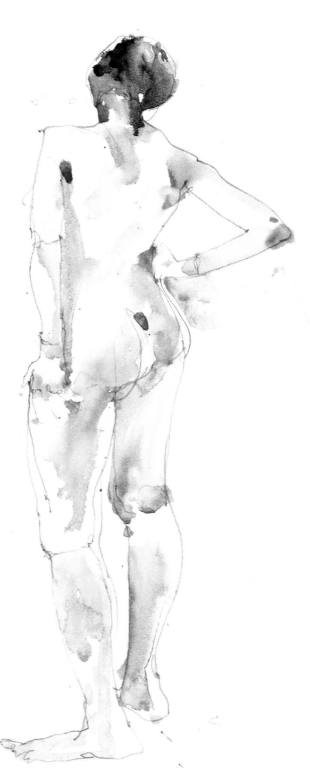

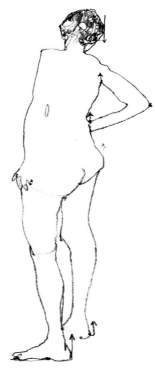

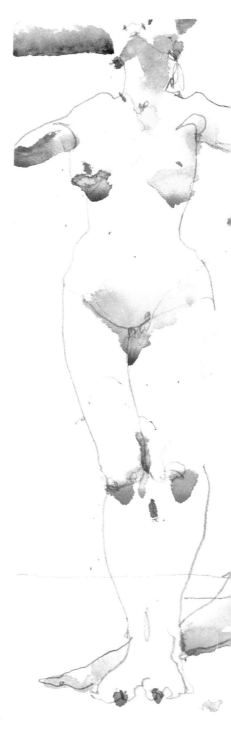

When rendering a figure, always carefully complete the head—even if it's the back of the head. You must have a reliable shape for reference as you continue with the rest of the figure. In the contour drawing above, done for the painting at left, I established the left shoulder and continued down the arm to the hand. I then went back to the right side of the neck and slowly contoured the right shoulder and outer part of the arm down to the hip. This is why it's critical to keep the pencil on the paper: As I work, I keep glancing up at the model to check my position in the figure in relation to a definite shape in the head. In this case, I used the hair shape on the right side of the head as my reference for the right side of the figure. The arrows indicate places on the body that align vertically.

STANDING MODEL
Whatman 90-lb. cold-pressed paper,
20 x 14" (50.8 x 35.6 cm)

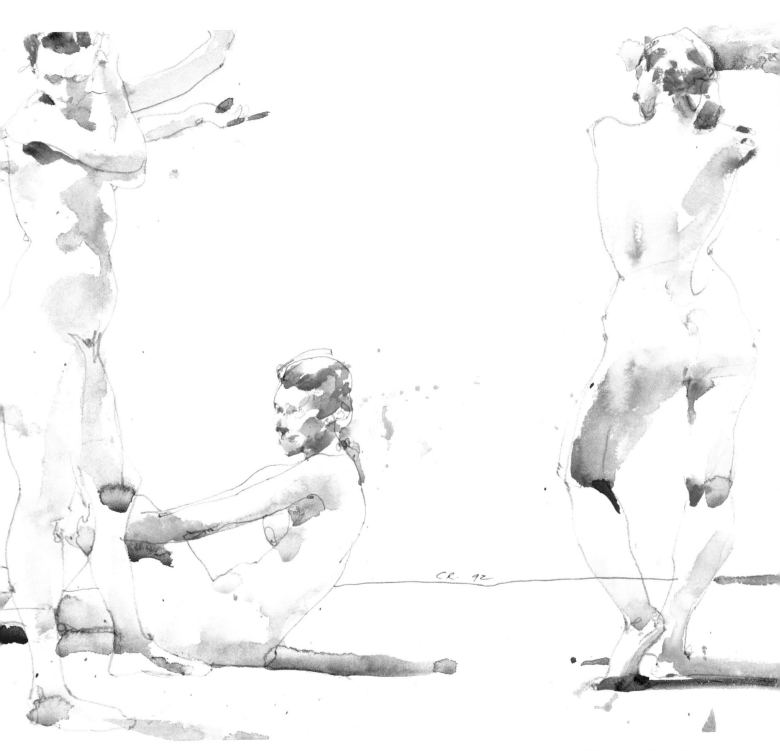

CR. 92

FOUR FIGURES
Whatman 90-lb. cold-pressed paper,
14 x 20" (35.6 x 50.8 cm)

I composed this painting using the same model in four different, rather extreme poses like ones you might encounter in a figure class. Try dropping an imaginary plumb line from various points in the heads down to various points lower in the figures. I hope you can see a valuable way of establishing a good gesture.

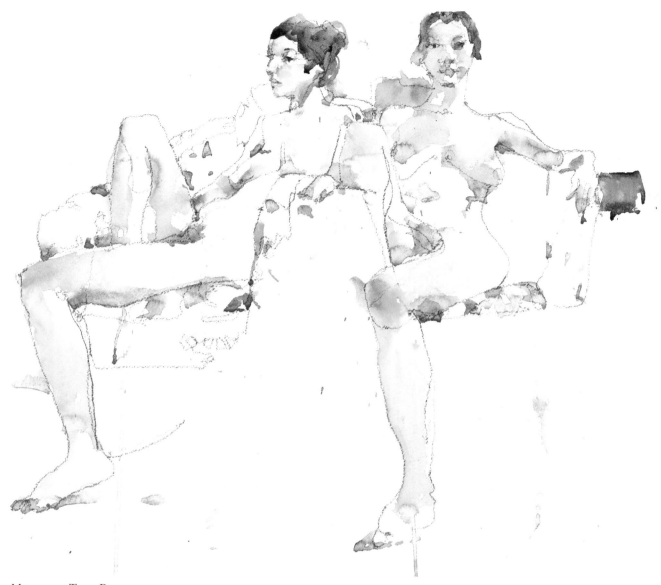

ONE MODEL IN TWO POSES
Fabriano 140-lb. rough paper, 18 x 24" (45.7 x 61.0 cm)

I started this painting with the figure at left, rendering the model as she took her first fifteen-minute pose. Then she turned toward me for the second pose, which also lasted fifteen minutes. The left-hand figure seems tired. The figure at right seems sprightly. Why? The figure on the left has no conflict; the pose lacks tension, and the different parts of the body are all "normal" in relation to one another. The pose, a conventional three-quarter view, is a big part of the problem. There's not much to exaggerate. Compare it with the pose on the right.

In this diagram of the two figures, I've tried to describe the difference between the lethargic and the vivacious simply by use of line.

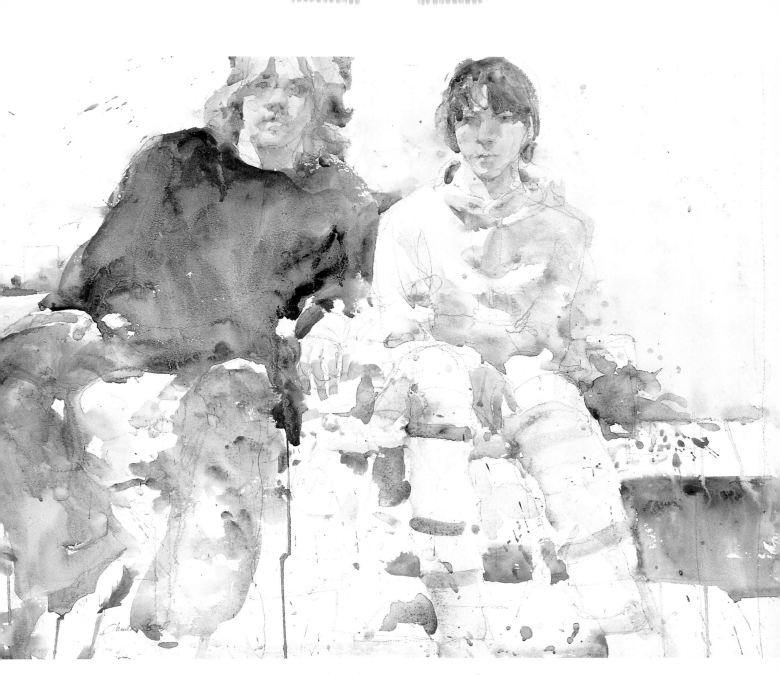

A STRAINED RELATIONSHIP
Whatman cold-pressed paper,
22 x 30" (55.9 x 76.2 cm),
courtesy Munson Gallery

Even though the models in this composition weren't
acquainted, the way they relate to each other through
their gestures is what makes the painting interesting.

Painting a Black Model

This lesson features a black model and is based on a typical sketch class. We'll start with some one-minute poses, then move on to ten- and twenty-minute poses.

If you've been following the book in sequence, by now you'll have practiced mixing flesh colors for dark complexions and done some gesture painting. Let's return to gesture painting as a warm-up exercise. Those shown below were done with a #10 round brush. You'll form shapes with your brush instead of filling in the boundaries of a pencil drawing. It's important to make broad, fat strokes with the body of the brush. Don't "nibble and peck." This step of the lesson is also good practice for attaining the proper ratio of water to pigment.

In longer poses of five minutes or more, I return to the pencil and make contour drawings before adding paint. The amount of watercolor work I do depends on the length of the pose. In all painting, we try for good color, value, and shape and are lucky if we can manage just one of these, even without a time limit. The great thing about short poses is that they teach us to accept mistakes and unhappy accidents.

The basic colors I use for a black model's skin tones are cadmium red, raw sienna, and cobalt blue.

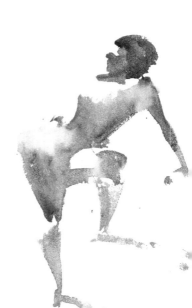

To get rid of a ragged edge at the end of a stroke, rinse and shake your brush, place it just below the ragged edge, and continue the stroke by brushing upward.

One-minute poses. The legs and arms of these figures were done with single strokes; try for a minimum. Don't work down from the head to the feet; in the figure at left I started with the face, then painted upward to do the arms, then added the hair wet-in-wet. I used mostly blue in the torso, painting downward and adding a bit of red when I got to the lower torso. Then I went to the knees with more red and raw sienna and painted upward to meet the torso. The other two figures were done in the same manner. I separated forms where I saw apparent light, leaving white paper in those areas.

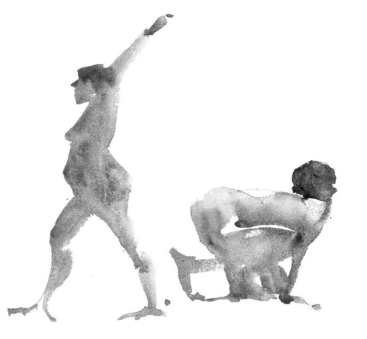

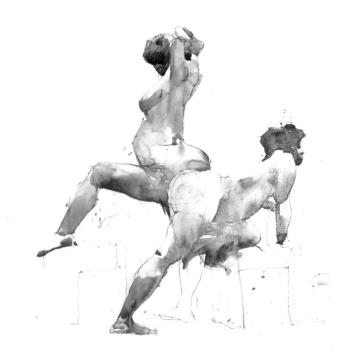

Ten-minute poses. As the model took her first pose (the kneeling one on the right), I aimed to draw her in five minutes. For a good, strong line, I used a carbon pencil.

Exaggerate the pose. Combine darker shapes of similar value (hair and face). Look for specific lighter shapes (features, shoulder, forearm, hip, lower torso). When you want a dark, precise edge, place the tip of your brush at the place you wish to accent, press down, and brush upward, lifting when you reach the halftone. This is how I approached the kneeling figure's right arm. Sometimes you'll end with a ragged edge; if so, rinse and shake your brush and, starting just below the ragged edge, brush upward to make a new stroke (see sketch, opposite).

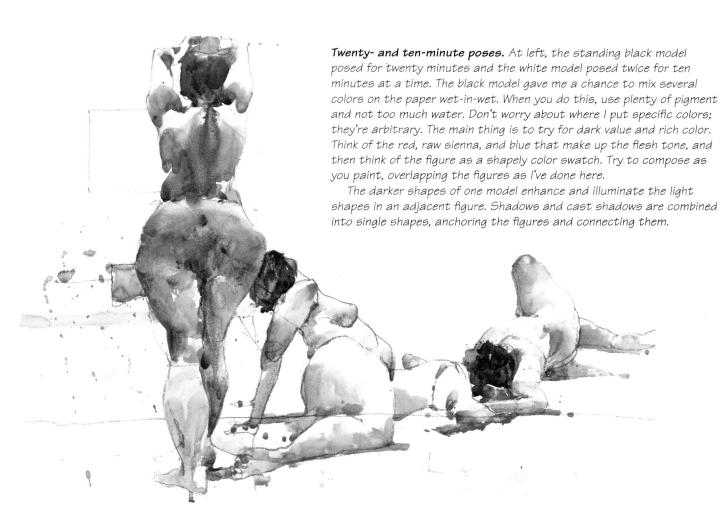

Twenty- and ten-minute poses. At left, the standing black model posed for twenty minutes and the white model posed twice for ten minutes at a time. The black model gave me a chance to mix several colors on the paper wet-in-wet. When you do this, use plenty of pigment and not too much water. Don't worry about where I put specific colors; they're arbitrary. The main thing is to try for dark value and rich color. Think of the red, raw sienna, and blue that make up the flesh tone, and then think of the figure as a shapely color swatch. Try to compose as you paint, overlapping the figures as I've done here.

The darker shapes of one model enhance and illuminate the light shapes in an adjacent figure. Shadows and cast shadows are combined into single shapes, anchoring the figures and connecting them.

Painting a Nude

I've chosen a foreshortened reclining pose for this lesson. (Study the small reproduction of the finished painting shown here.) Reclining poses can be difficult, since we more easily register sitting or standing poses. This means you must really *see* and understand what you're looking at. Contouring is especially helpful in a pose like this. Foreshortening is scary, but if you go to sketch classes, it's bound to happen. Never let yourself assume anything. Always measure and compare. With your arm straight, hold a pencil so the tip of the eraser aligns with the top of the model's head. Place your thumbnail on the pencil in alignment with the chin. This establishes the model's head length. Work your way down the figure using the head length as your measuring tool. Although you can't actually see the model's chin in my painting, you can imagine it. You should be able to see that the figure is about five head lengths high.

As you work, make sure to weave your figure with the background forms. Most of all, make your figure big in relation to your paper. Don't attempt a full sheet; 18 x 24" is fine. Cutting a full sheet in half

is okay, but results in a format that's too rectangular for most situations. Backgrounds are difficult, so the bigger the figure, the less background you'll have to worry about.

I did this painting using a #10 round sable brush. For the skin color I used

cadmium red light, cadmium yellow pale, and cerulean blue, with yellow ochre or raw sienna in place of the cadmium yellow for the darker skin tones. In the background I used burnt and raw umber, ultramarine and cobalt blue, mineral violet, and cadmium red and orange.

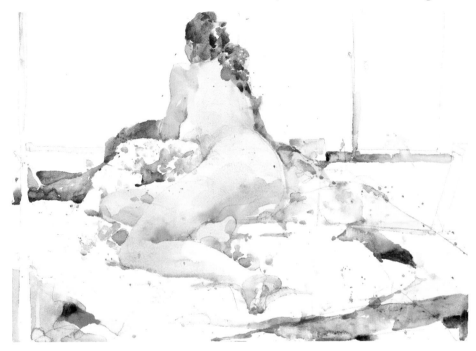

I work my way down the figure measuring five head lengths, then add one more. This method isn't always accurate, it's just an aid, so I add a half or a full head length to make sure I get decent proportions. It's better to have the head smaller than larger if you want to express foreshortening. There are about three head lengths from the shoulder line to the left foot, which curls behind the knee, but don't worry about exact measurements; you just need to understand that the lower part of the figure is bigger than you think.

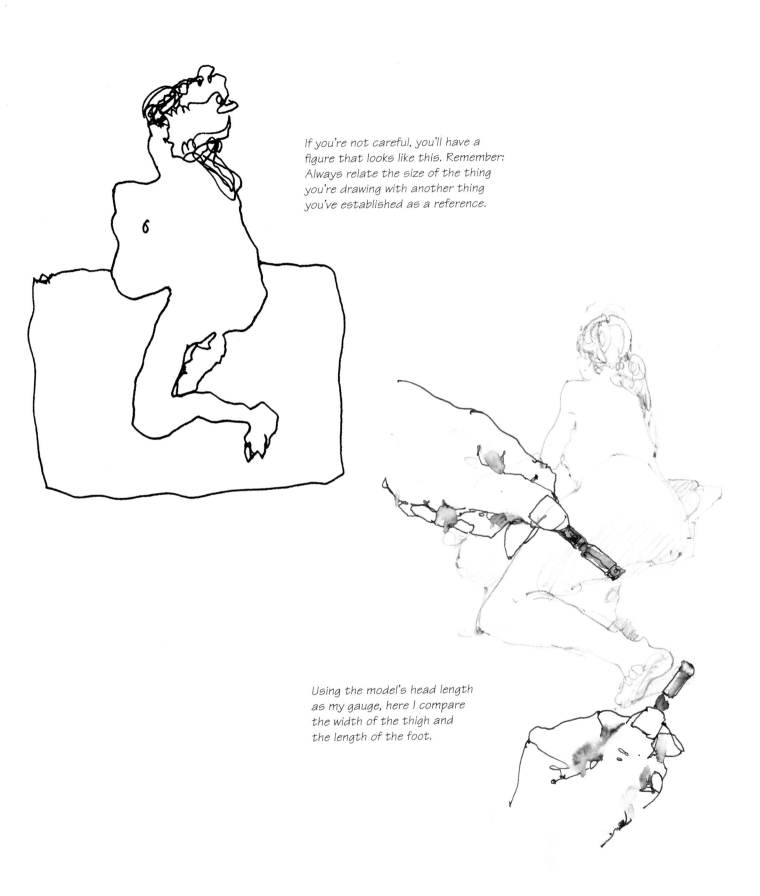

If you're not careful, you'll have a figure that looks like this. Remember: Always relate the size of the thing you're drawing with another thing you've established as a reference.

Using the model's head length as my gauge, here I compare the width of the thigh and the length of the foot.

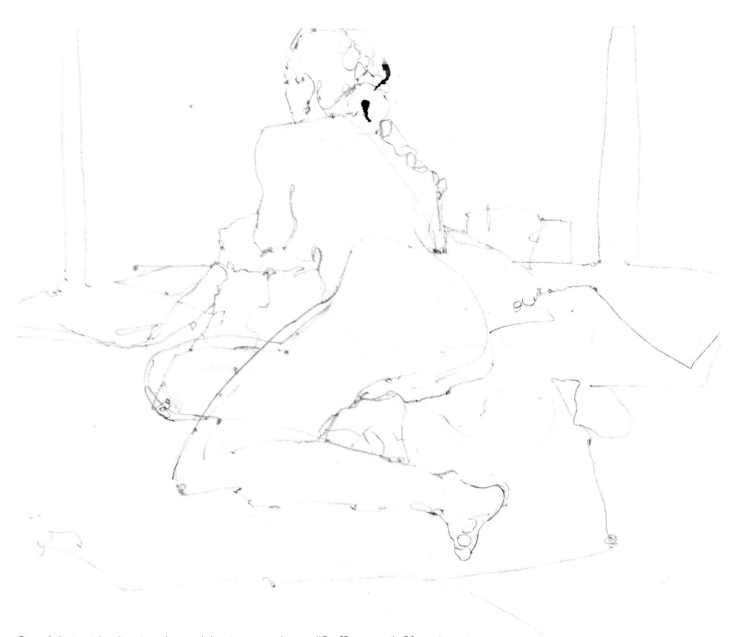

Step 1. *I start by drawing the model using an ordinary #2 office pencil. Often, I must make two or more such drawings to get things right. It seems a waste of paper, but erasing doesn't usually result in good corrections and tends to mess up the paper. You'll notice the trouble I'm having getting the upper legs wide enough and long enough. Instead of erasing, I make new lines using the original ones as a reference for my corrections. I keep the pencil firmly on the paper. Each line is a commitment; sketchy, tentative lines won't do.*

My palette looks like a color swatch. The idea is to be able to see the makings; don't overmix and make a brown mess like the blob below.

Step 2. As a rule, the face, arms, and legs will be warmer, so in these areas I use a combination of roughly two-thirds red to one-third yellow, leaving out the blue. The torso is cooler, so here I use cerulean, adding some of my red-yellow combination. Don't worry about the warm-cool business. It's more important to achieve a large, clean first wash at one go. If you miss a few specks of white paper, don't go back or you'll ruin your wash.

Ignore my background colors. The main thing is to paint OUT of the figure and into the surroundings. Try to reach three picture boundaries. Here, I hit all four. At this stage, DON'T use any middle or dark values in the figure. I did use some in the background to establish a reference for comparison later.

Notice where I crossed boundaries with this first wash: face into hair, left arm and lower torso into the background. Crossing boundaries is the most important and difficult part of this step. Note that VALUES remain the same as I do this. I go from warmer into cooler colors, but the values stay the same. If I add darks next to the still-damp figure, they'll flood in and destroy her complexion.

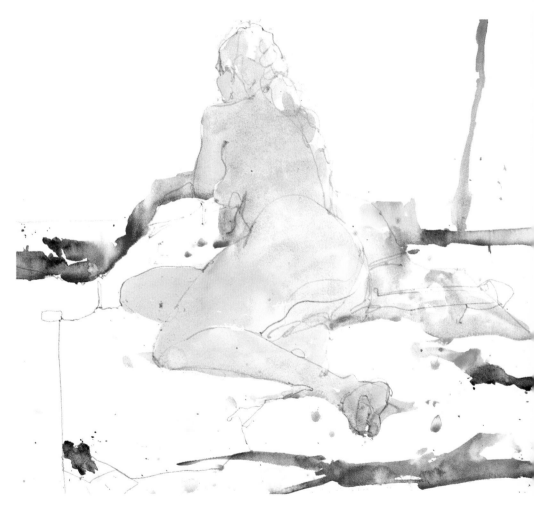

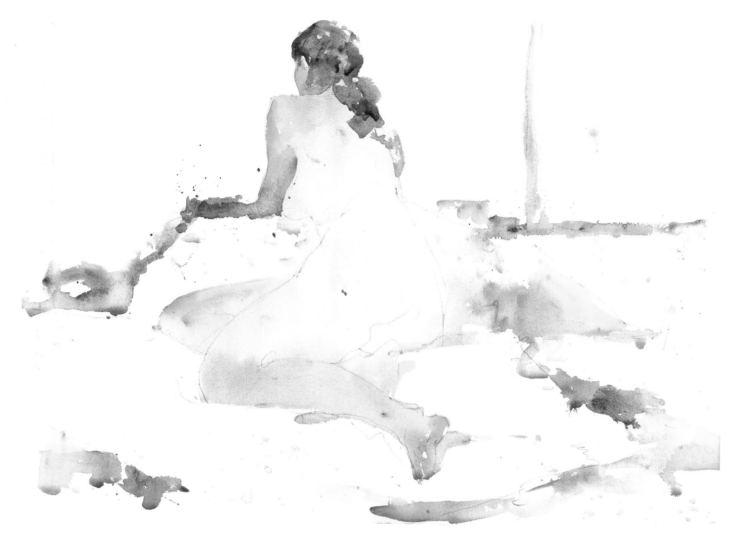

Step 3. Check your first wash. Most areas should be fine; our goal is to paint over only about 30 percent of the figure. MAKE SURE THE FIRST WASH IS COMPLETELY DRY BEFORE YOU PAINT OVER IT. I use cadmium red and a touch of cadmium yellow pale in a slightly richer wash over the face. In the left arm, I again use cadmium red, but this time add a touch of yellow ochre. I paint UP from the elbow and, with the same colors but less water, add some accents next to the breast and upper torso wet-in-wet. I work to and around the shoulder, stop, and soften.

The face isn't quite dry. I use almost pure red and a touch of yellow ochre behind the ear. Then, with cobalt blue and raw umber, I add the hair, leaving some areas white for texture.

Notice the "bleed" where the hair merges with the still-damp face. Where it's a bit darker, above the cheek, I used more pigment and less water as I worked wet-in-wet. As the hair dries I add some accents, using ochre or raw sienna with my umber and a touch of carmine for the ribbon.

Next to the elbow I paint some Holbein's peacock blue. I lay the paint down about a quarter of an inch to the left of the elbow and leave a space, since the elbow is still damp. If I were to paint the blue right up to the elbow, the color would flood in and destroy this form. In this example you can see a bridge of more neutral color just to the left of the elbow where the flesh color and the blue merge.

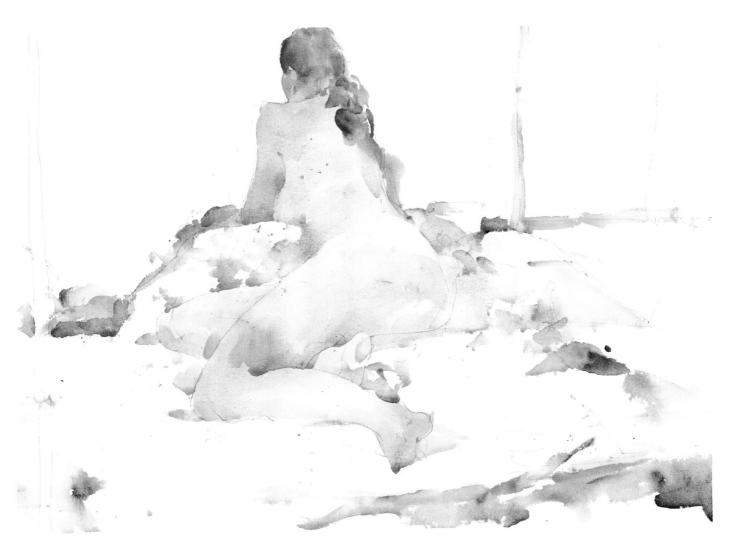

Step 4. I define some boundaries. Notice how the touches of background color start to bring the legs and hip into focus. I use just short "pieces" of color to do this (at the ankle, knee, and top of the model's right thigh, for example); NEVER isolate a whole form with a long, constricting background shape. I make sure that other boundaries remain "lost," as in the front of the stomach, the area where the hair merges with the face, and where the model's derrière merges with the cast shadow on the floor.

At this stage the painting should have some very carefully shaped darks to provide the contrast and firm edges needed to define form. In defining the calf, for example, I start behind the knee with a mixture of cadmium red light and yellow ochre, and as I move along the top edge of the form, I add cerulean blue. Make sure you work out into the picture and don't get stuck in the figure.

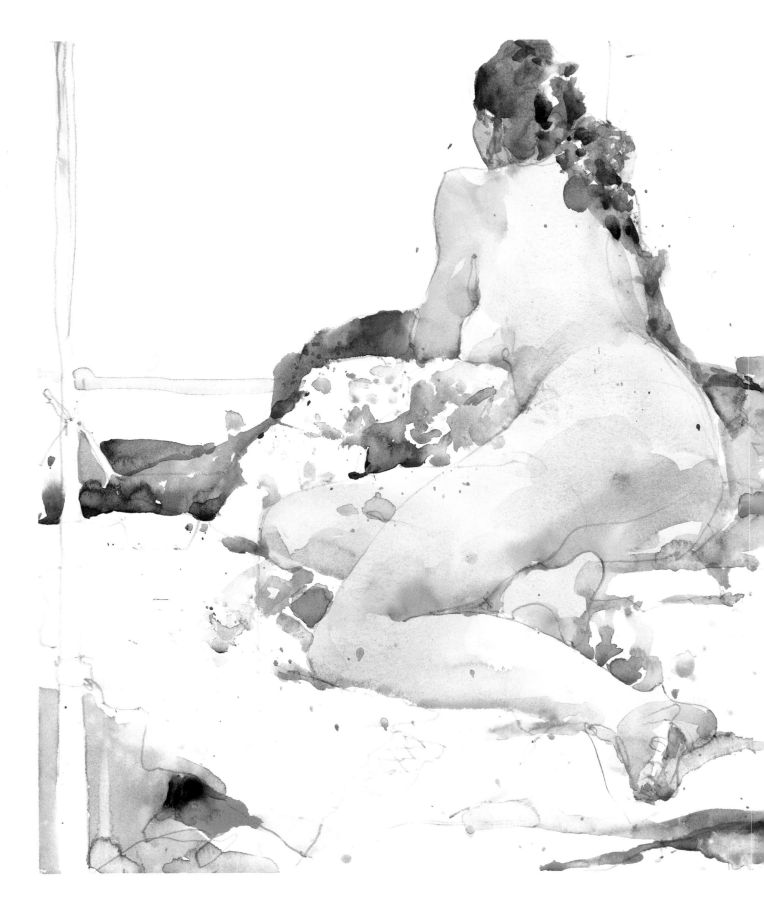

Step 5 (finish). *The biggest problem with finishing a painting is the wish to make it just a bit better, to add just a bit more. Here, I left a lot of white paper because I didn't know what to put in. If you don't know what to add, don't add anything. Leave some mystery. Think of all the wrinkles and details I could have put in. There's nothing wrong with doing this if you have "perfect pitch" in your values—but most of us don't, so it's better to leave such things out.*

Keep your figures simple. Don't try to model with your brush. I achieved all of the light areas in this painting in the first wash, where I used color changes of the same value to show form—warm colors in the legs, shoulder, and arm, and cool colors in the breast and lower torso.

Don't stress details in shadow. Shadows are places to simplify. Look at the model's bottom and note how the shadow shape obscures the details. I stressed instead both ankles with strong color and value contrasts. That's where the eye will look, bringing these elements forward.

Take advantage of darker surrounding shapes to illuminate your figure. If you leave them out, you'll concentrate too much on modeling and will overwork the figure.

SUSAN
Winsor & Newton 90-lb. cold-pressed paper,
18 x 24" (45.7 x 61.0 cm)

Painting a Clothed Figure

This lesson, a re-creation of a painting I did in a sketch class, shows how I connect and unify disparate parts of the figure. The pose offers many temptations to separate forms: the hands and fingers from the face, for instance, or the black clothing from the skin tones. Squinting, however, allows me to see my subject in terms of values; I connect areas that are of similar value while showing the variations in color that occur within them. Here, for example, I differentiate the model's skin from her clothing by using a warm color for one and a cool color for the other, but keep things unified by making these colors the same value in certain areas. I leave separations wherever I see contrasting values when I squint at the model.

I don't have a fixed working method; I approach every painting a little differently. In this case I established the darks in the eye, eye socket, and the tip of the nose with my first wash. These values describe the subject and are called *positive shapes*. Even in the first wash it's good to find a dark *negative* or background shape as a balance. Look at the finished painting on page 118, where you can see how nicely the hat accomplishes this; it helps bring the eyes, cheek, and nose into focus.

Except for the darks just mentioned, we'll be using light and middle values, traveling between adjoining areas and making some color changes. Don't attempt to connect all the forms—the paint will dry and you'll have unfinished washes with hard edges in awkward places.

I worked on 18 x 24" cold-pressed paper, using a #9 round brush in the face and a #11 round to paint the body. For the flesh color I used cadmium red light, cadmium yellow pale, raw sienna, and cerulean or cobalt blue. For the clothing I used ivory black, ultramarine blue, alizarin crimson, burnt umber, and burnt sienna. You don't need all of these colors; ultramarine blue, burnt sienna, and black would do nicely, as you can see in the swatch below. For the surroundings I used cadmium orange, cadmium yellow, cerulean blue, and raw sienna.

Avoid overmixing on the palette. Mix on the paper and don't homogenize the colors. You should see individual colors in places. Paint a given area just as if it were a large color swatch.

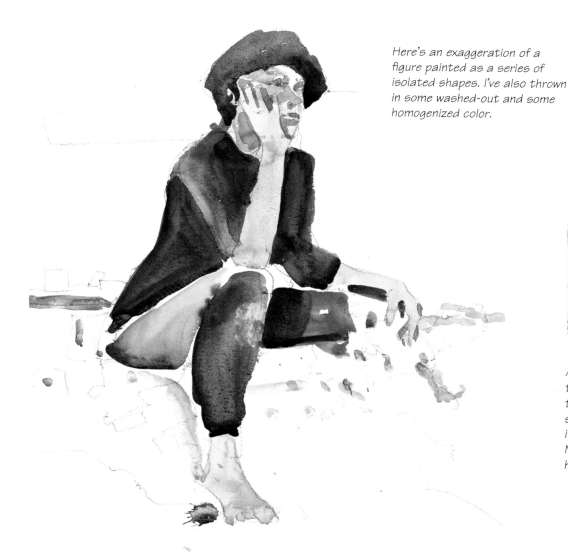

Here's an exaggeration of a figure painted as a series of isolated shapes. I've also thrown in some washed-out and some homogenized color.

Although I used more colors to paint the model's clothing, those shown here—burnt sienna, ultramarine blue, and ivory black—are sufficient. Note that I haven't homogenized the colors.

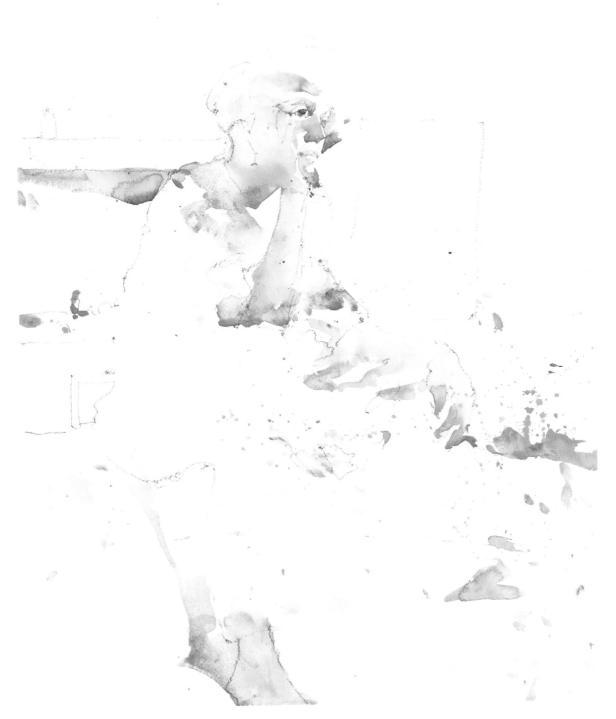

Step 1. Start by establishing careful eye, eye socket, and nose shapes in fairly dark values. These features are the nucleus for the rest of the painting and should almost be finished in this early stage; they are the most important areas, so aim to be correct as you define them. Try to get the value right on the first try. NO OVERWASHES.

Think of this first wash as a color swatch with definite shapes. In my original, the distance from the head to the elbow is about 7". Mix cadmium red, a bit of cadmium yellow pale, and cerulean blue. Paint the face, working your way into the torso and arm in one continuous, flowing effort. You must be able to see and control the shapes. You shouldn't have to correct this wash; it needs to be fresh and clean.

Once you're satisfied with the head and arm, continue leftward over to the picture border with raw sienna and cerulean blue, then down to the right of the composition into the model's left arm and hand. I added some red and raw sienna at the fingertips to give them dimension.

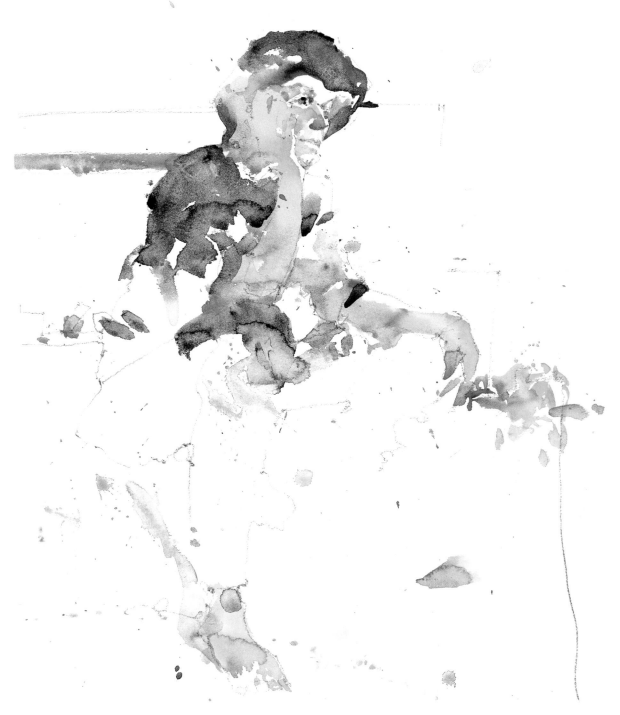

Step 2. *I've left some spaces so you can see the direction and size of my brushstrokes. Remember to use the side of the brush, and never paint your strokes all in the same direction.*

You should enhance lighter forms with darker shapes but never in such a way that you trap and thus isolate the lighter areas. At this stage I have many "escape routes" and blurred areas where still-damp adjacent forms run together. This is the time to keep a painting moving. Don't tighten up. Compare the areas of definition with the blurred, undefined, and "lost" elements. At this point they should exist in equal amounts.

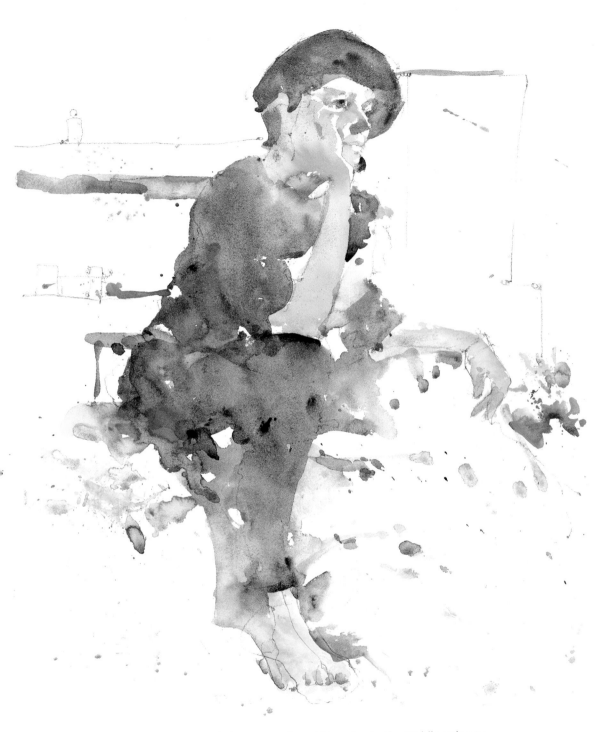

Step 3. *The model is wearing black, but try to keep this color in the middle-value to mid-dark range. Don't isolate the face by making the hat too dark. I want the nose to project, and if I make the hat black next to it, the hat will project instead. The neckline of the shirt is faded a bit so that there's still an easy transition into the neck. I want the front of the leg to project, so I combine the back of the leg with the cast shadow. Finally, compare the value in the closer sleeve and knee with the far sleeve. Why didn't I make the values all the same?*

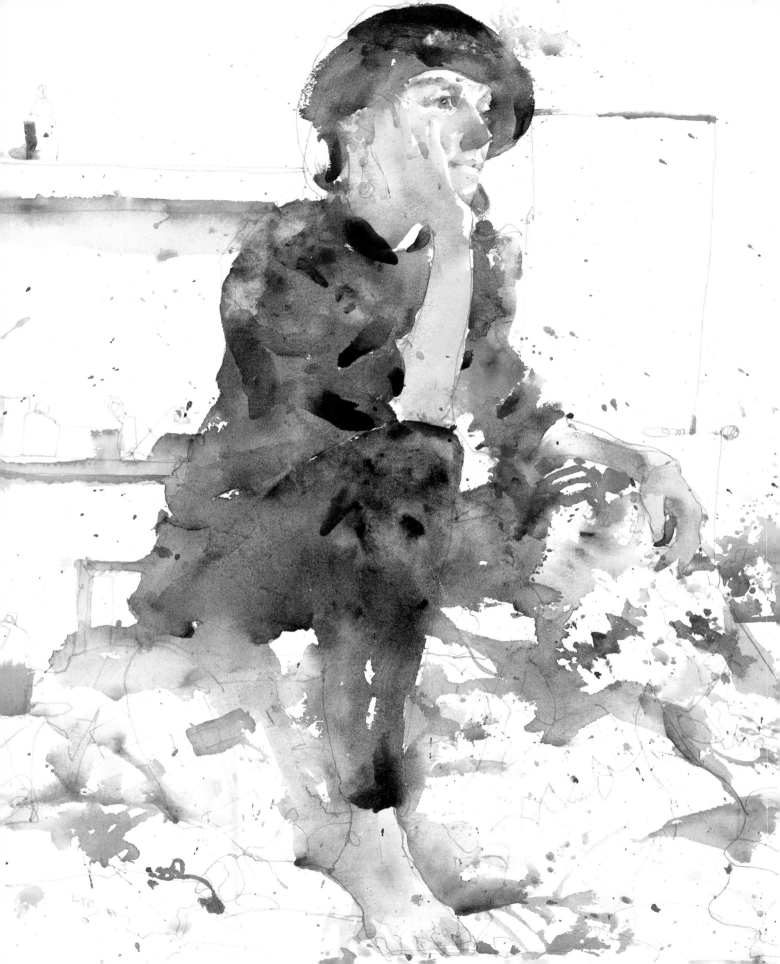

Step 4 (finish). *The whole idea here is to decide what areas I want to emphasize. Too often, students become recorders of facts and details. Look at the hand next to the face; the fingers were interesting and called for attention. Why did I practically ignore them? Always compare the relative importance of one area with another. Since I was most interested in the face and knew the hand would be a monster to paint, I concentrated on getting definition in the face.*

This painting isn't literally finished. I wish the area under the hand that rests on the knee was done better, but there was an ugly pattern in that part of the setup. I'd rather leave an area like this with a few spots of color if I don't know how to handle it. Think also of your energy level. If a pattern like this still needs attention toward the end of the session, you'll probably mess it up, and consequently mess up the whole painting.

Final advice: Don't paint something the way it looks without comparing it with something else. Work with deliberation. Spontaneity is only an illusion.

CLOTHED MODEL
*Fabriano Artistico cold-pressed paper, 24 x 18"
(61.0 x 45.7 cm)*

INTEGRATING FIGURE AND BACKGROUND

Never start a painting thinking only about the subject. If you do, you'll tend to become involved with anatomical details and forms and will end up with fussy, fragmented results. Instead, look beyond the subject into the background. Squint to see where there are definite contrasts between the figure and background, and where there is little or no contrast. This will help you determine the best places to link your subject to the surroundings. The background is always the hardest part of a painting, so you should force yourself to deal with it early on. Think about how much background you want. It's a good policy to make the figure as large as possible so you don't have to deal with a lot of background.

The exercises presented here will help you see that painting the background at the same time that you work on the figure is the only way to make the two entities relate to each other organically.

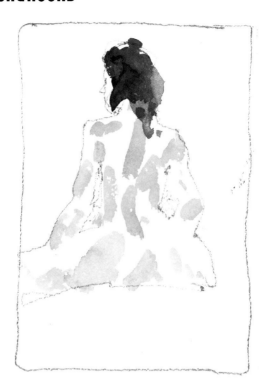

If you think only about your subject and not about the background, you may find yourself painting with fragmented strokes like these.

Draw your figure subject, then draw a frame around it that corresponds to the proportions of your prospective painting. (Here I've done very little drawing, just the barest indication of the model's hair, arm, and the adjoining negative shape.) Don't paint the figure; instead, paint the middle-value and dark shapes that surround it. These are your negative shapes. Don't completely fill in the areas around the figure; leave some white paper where the model and background are similar in value. You must squint to see this. The negative, background shapes vary in size as well as contour. Make sure some of the shapes meet the picture "frame." Although the design is abstract, you should see a figure emerging without actually painting it.

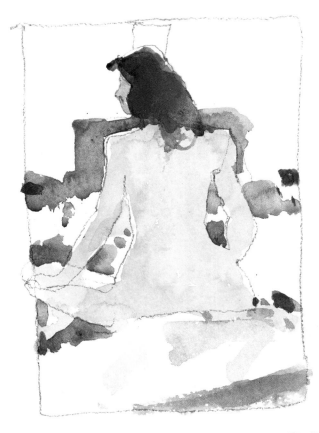

Some students have a hard time seeing value differences, often confusing them with color differences. Also, there's a tendency to make everything one middle value. Let's do a value sketch using just ultramarine blue and raw sienna. Make a contour-type drawing of your composition. Next to it draw five blocks, making the first one very dark and lightening each successive block, ending with a white one. Squint to study your subject. Try to find a place in your sketch for all five values. You don't have to fill in the whole picture; just make sure you have a definite range of light, middle, and dark values. Here, I decided to use just one value for the entire figure. Don't get into small forms. You want a homogenized single value that accurately describes the figure as a whole. Start with some of the middle-value background shapes so you have something to compare with the figure.

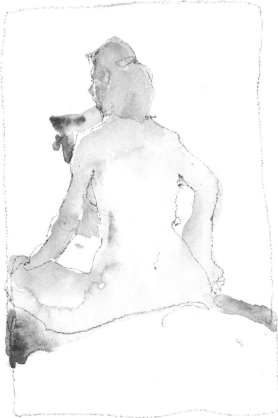

Get in the habit of "painting out" of the figure. If you have a darker value next to the figure, paint the skin tones out, then make a color change wet-in-wet. Make sure you leave a "safety zone" of skin tone so that the background color doesn't flow into the figure.

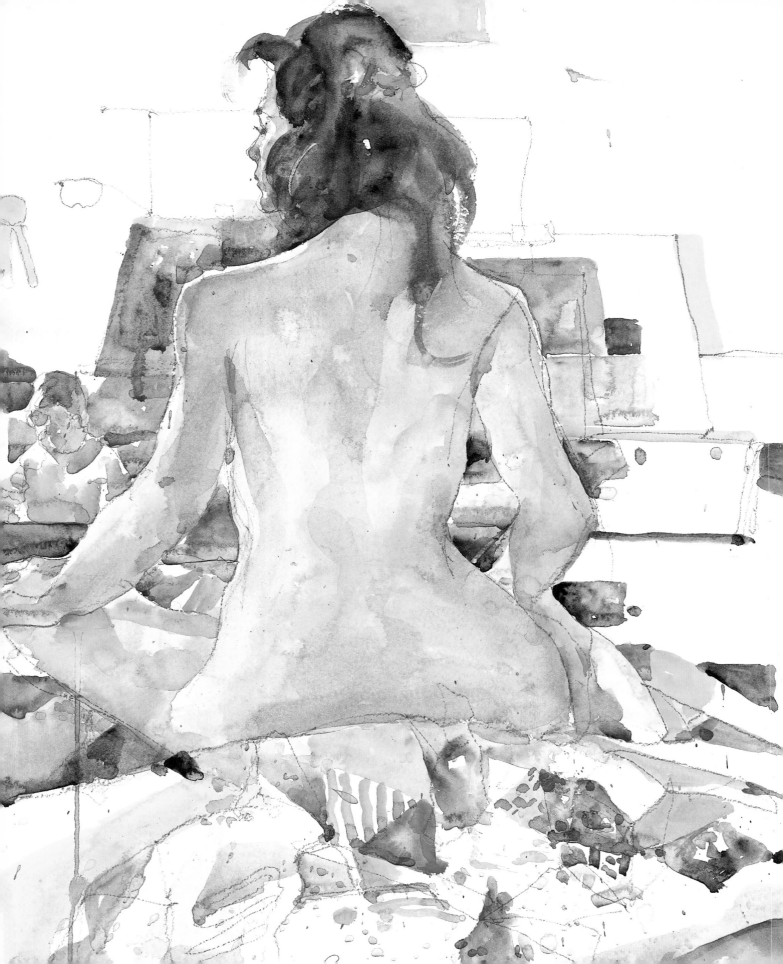

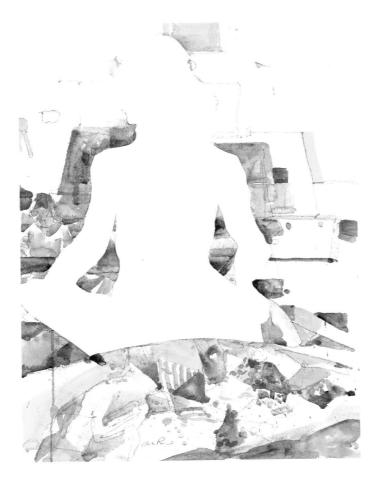

If you've done your homework, you'll realize that the background shapes carry the figure. I have enough darker values around her so I don't have to do a great deal of modeling within the figure itself. Because my subject is backlit, her skin tones are basically all one value except for the light on the shoulder, legs, and arms.

TAMA
Fabriano Artistico 140-lb. rough paper,
22 x 18" (55.9 x 45.7 cm)

In the beginning I pay close attention to my subject, trying not to be literal, but rather to translate what I see in terms of painting. As I progress, I begin to use my painted image for reference as well as my model and her immediate surroundings. In this case, I saw the quilt as spots of color and value, and slowly and carefully selected the bits of pattern that would balance and enhance the images already on the paper. I stopped after painting each piece of pattern and assessed its effect on the whole painting. Never let yourself get so immersed in a single area that you carry it too far, making it dominate. Often I use a piece of pure color arbitrarily for balance, like the yellow area at the top in this example. This takes a lot of practice, but you must work toward the point where the painting itself starts to suggest ideas. I painted Margaret, the figure at far left, to counter the many anonymous abstract shapes in the composition. It's impossible to explain why I chose Margaret from among the roomful of people and left the others out, except that at a certain point painting ceases to be a rational process and becomes intuitive and whimsical.

Make sure your subject can breathe. Don't isolate your figure with a solid surrounding of continuous darks. Note the value variations within my darks where they meet the figure's boundaries. Weave your figure with the background, making separations and connections.

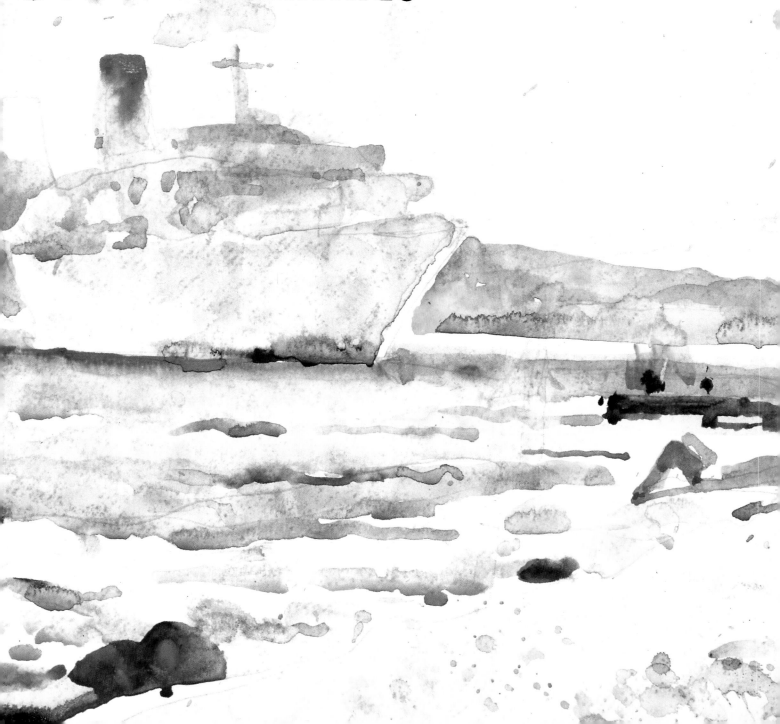

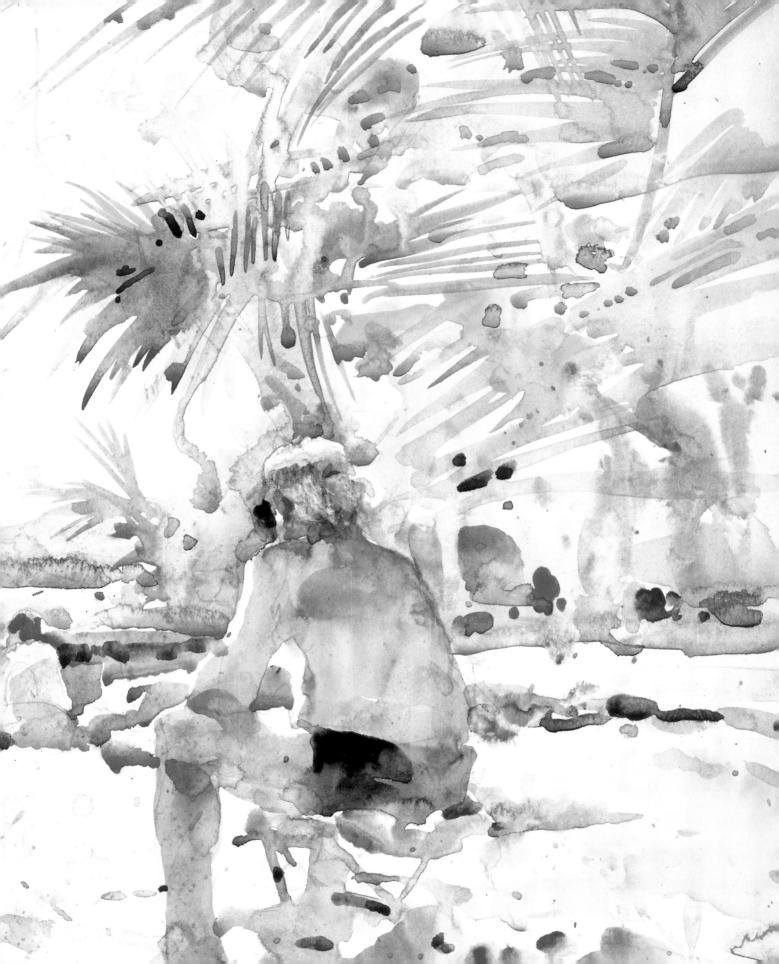

COMPOSING WITH SKETCH CLASS FIGURES

Sketch classes can provide you with a new dimension to your figure-painting experience: composition. In my own sketch class work, I like to paint one figure (usually in a twenty-minute pose), then make a composition by combining it with the next pose. I don't like to plan compositions, and, since I never know what the next pose is going to be, this gives me a chance to work things out as I go. In fact, most of the multiple-figure compositions you see on these pages were done this way.

Always consider the whole sheet of paper; never think of your figures as isolated and unrelated to the edges of the page. Connect your figures to one another, and use negative background shapes to connect them to the picture borders. I like to relate my figures to at least three borders, even if only with a pencil line. In the nineteenth and early twentieth centuries, artists like Edgar Degas, Edouard Vuillard, and Pierre Bonnard ignored rules that said not to put important elements and strong colors near borders, reflecting in part their apparent interest in the compositional "accidents" that happened in the then relatively new medium of photography. I've patterned my compositional thinking after these painters. Quite simply, I like my pictures to be happenings.

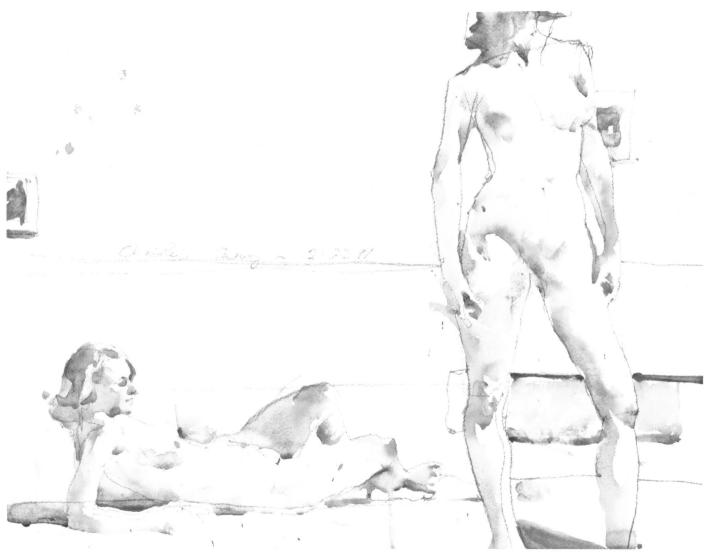

RECLINING AND STANDING MODELS
Old Dutch Aquarel 140-lb. cold-pressed paper,
15¾ x 19½" (40 x 49.5 cm)

When there's little in the background you want to deal with, crowd your figures within the picture space. I made my standing figure so large that I had to crop parts of her out of the picture.

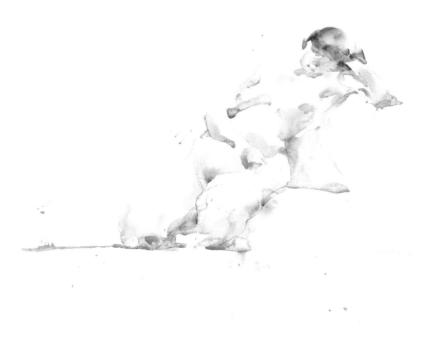

RED HEAD
Whatman 140-lb. cold-pressed paper,
16 x 24" (40.6 x 61 cm)

Always find places where you can flow
from one form to another without a stop
in between. Notice how many boundaries
I've painted across to make connections.

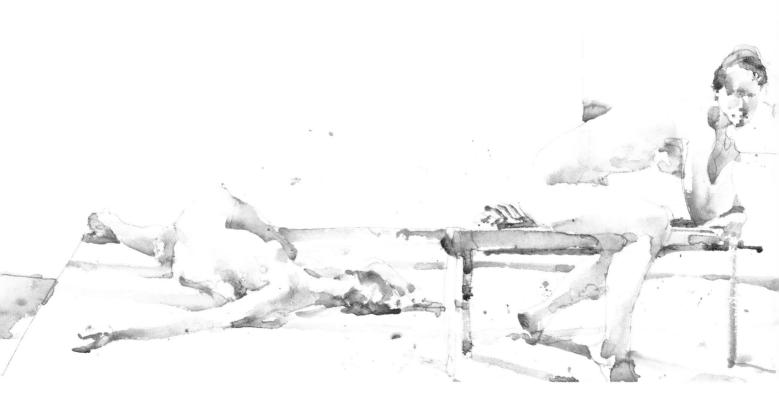

TWO VIEWS OF JANET
Winsor & Newton 90-lb. cold-pressed paper,
14 x 20" (35.6 x 50.8 cm)

Always think of negative shapes, even segments of negative shapes,
that can bring lighter forms into focus. In the figure at right, note how
just the small negative triangular shape establishes the model's back.

FLATTENING THE PICTURE PLANE

It's important to understand how color, value, and edge control give depth and perspective to a painting. We shouldn't, however, be slaves to the "rules" of perspective. In fact, I often ignore them. Some of our most interesting painters didn't understand perspective or how to create the illusion of depth. Among them are the fifteenth-century Flemish master Jan van Eyck, the early Renaissance artists Piero della Francesca and Paolo Uccello, and, in our own century,

Horace Pippin and Grandma Moses, all of whom portrayed their subjects on one picture plane.

Some of the best-known French artists of the late nineteenth and early twentieth centuries, including Paul Gauguin, Edouard Vuillard, Pierre Bonnard, Paul Cézanne, and Henri Matisse, knew about perspective but chose instead to flatten the picture plane, bringing distant objects closer and pushing closer objects back. This

visual "push and pull" causes tension within a painting.

Traditional perspective rules prescribe how distant objects should be a certain value or color and closer ones another value or color, and that objects in the light should appear warm, while those in shadow should be cool. But such rules have too many exceptions to be taken altogether seriously. If a spot of intense color or dark value in the distance helps my design, I use it no matter what.

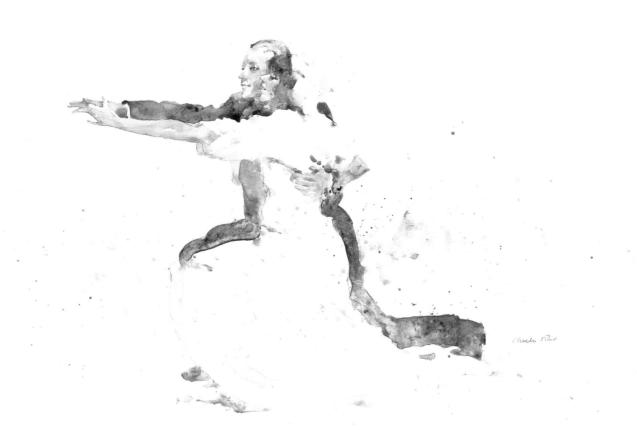

TANGO PROJECT
Strathmore 2-ply hot-pressed illustration board, 20 x 20" (50.8 x 50.8), courtesy Electra Records

I wanted the two figures—Vernon and Irene Castle—to be part of each other. Here, their faces are on the same picture plane, and Vernon's black jacket merges into Irene's hair. The main trick was to make his clothes obviously dark against her white dress. I subtly isolated the two shapes by lightening parts of the suit so they would merge with the dress. There's hardly any detail in the dress, because I wanted it to look extraordinarily white. All it needed to give it substance was some dark negative shapes.

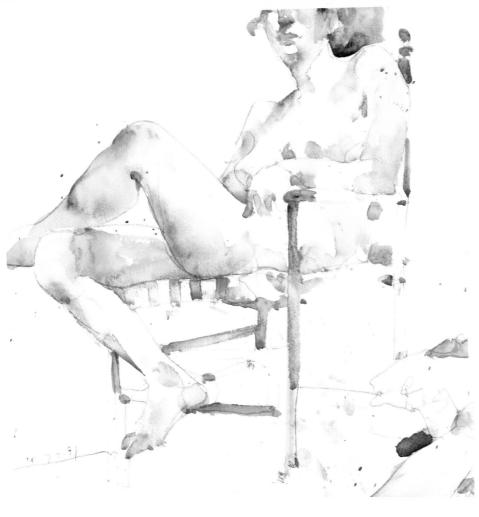

MODEL IN ARMCHAIR
Winsor & Newton 90-lb. cold-pressed paper,
13 x 11¾" (33 x 29.9 cm)

I cropped out the top of the model's head so I could concentrate on the face as a selection of color and value shapes rather than as a collection of features. These shapes are incorporated with the dark form above the shoulder, which isn't background but a continuation of the shapes in the face and hair. The chair is almost more important than the figure; it, along with the negative shape next to the head, give the picture structure.

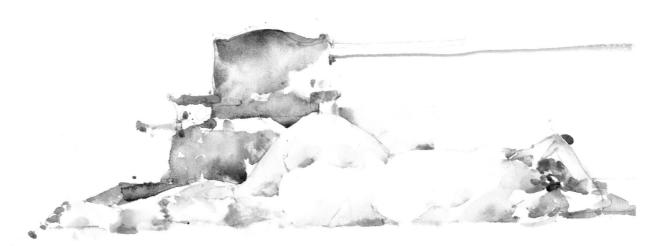

MODEL AND CHAIR
Winsor & Newton 90-lb. cold-pressed paper,
14 x 20" (35.6 x 50.8 cm)

To catch the lovely, simple grace of the model, I had to go beyond her boundaries. I painted a few forms in the figure, then the "overwork" light started blinking. This is a place for important background shapes. Get out of the figure as soon as you can. If you start adding details and small forms, your figure will start looking like a medical illustration. Paint your model with surrounding shapes. Here, the hair is the only dark within the figure. I added some color notes in the feet, but then I needed to go outside the figure to the cast shadows and the chair to give her substance. In this composition, the background dominates the figure.

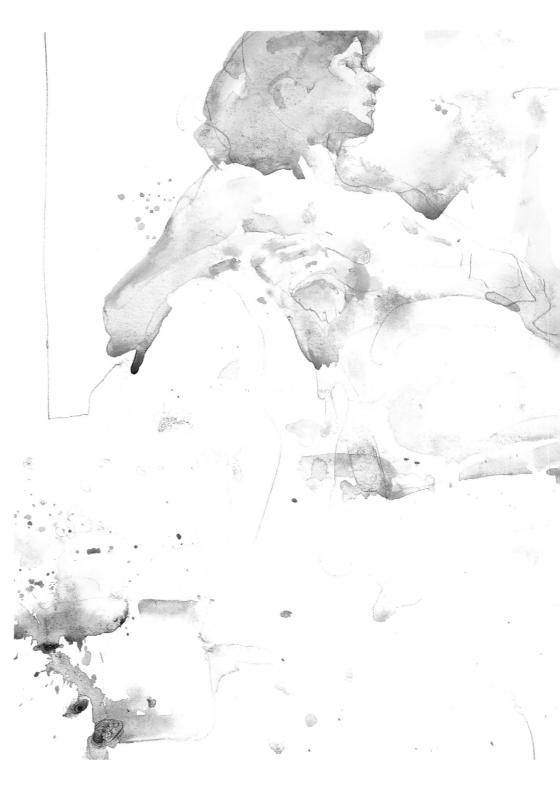

FIGURE ON WHITE COUCH
Cold-pressed sketchbook paper,
12 x 20" (30.5 x 50.8 cm)

The warm, dark negative shape and hard edge want to bring the far arm forward, almost fighting the blue cast shadow below the hands. I made the red and black pillows by the model's feet the strongest color and value areas in the painting because they balance the head and the darker shapes mentioned above. Look at Hilton Head on page 73. There, I placed the red and blue background and foreground shapes purely for the structure of the picture, disregarding depth completely.

KRisten- Longmont CO.
1.28.86

RECLINING NUDE
WITH BLUE BACKGROUND
Cold-pressed sketchbook paper,
12 x 20" (30.5 x 50.0 cm)

Invert the book to look at
this painting and you'll see
that the composition is really
about color and value shapes
rather than a figure. The hair,
a relatively strong color, and
the elbow, a darker value, are
balanced by the strong blue
next to the model's hip and
the black shape by her foot.
I often use value (here, the
black area) to balance strong
color, and vice versa. However,
never think ONLY of value
when you need to balance
or strengthen a painting.

KRisten- LongMont CO. n 1·26·86

anama /.

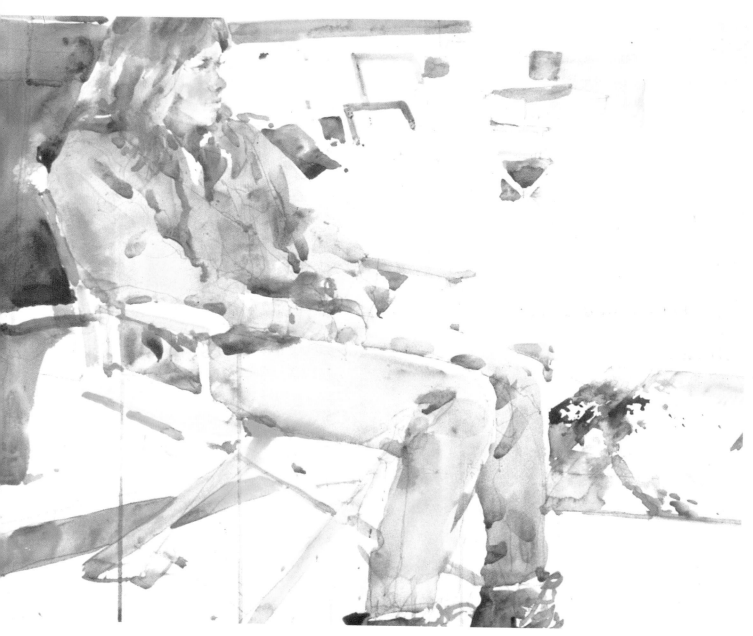

**SARAH IN HER OUTWARD
BOUND BOOTS**
*Winsor & Newton cold-pressed paper,
18 x 24" (45.7 x 61 cm)*

I used darker background shapes and middle to lighter values in my painting of Sarah. If you squint, you'll see that the negative background shapes come forward and Sarah almost disappears. These background shapes force the eye to move through the composition. Although I want the viewer to see Sarah, she shouldn't dominate. If she's too important, the viewer's eye will stay on her and not move through the picture.

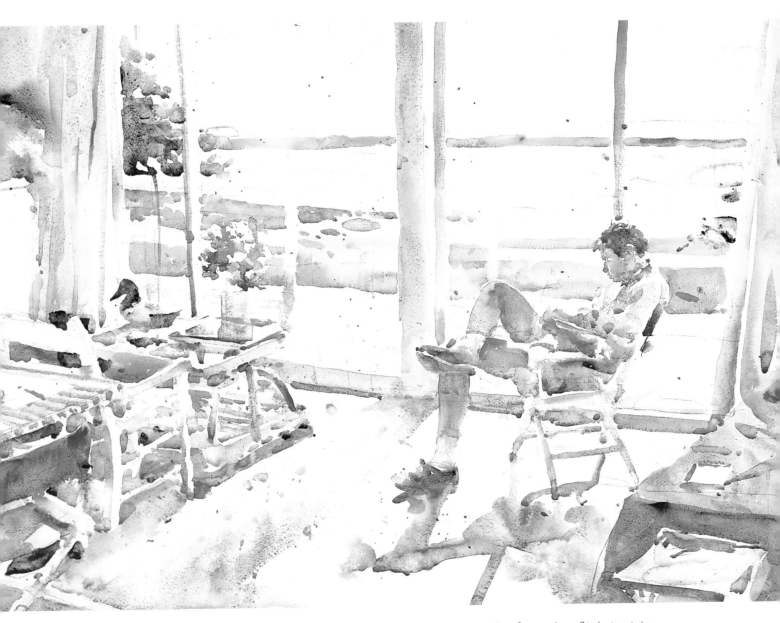

PETE IN BACCARO
Winsor & Newton cold-pressed paper,
22 x 30 (55.9 x 76.2 cm)

Painting from life defies planning. Peter was reading for my benefit, but a trip in his dory was on both our minds. Our house faces east. The sun seems to fly. Unfortunately, many painters don't want to deal with this immediacy. It's a grand experience, with every possibility of failure. Get someone to pose in a chair and paint him or her as best you can, making sure to include the adjacent background shapes. After an hour of painting Peter and a "Thank you," the chair stood empty, a lonesome reference for the rest of the painting.

CHOOSING THE ESSENTIALS

Good painting is about leaving things out. We all see too many values and separations, and have a hard time editing out and simplifying several values into just one or two. But, if your subject consists of four shapes, try for three, or maybe even just two, in your painting. If your subject consists of two shapes, try for just one.

This is another way of saying "Simpler is always better" or "It's not what you put into a picture that counts, it's what you leave out." We've all heard this excellent advice but rarely put it into practice.

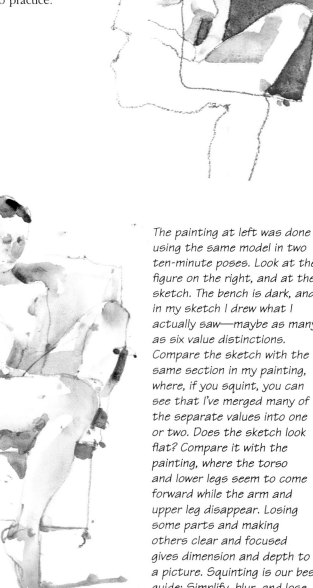

The painting at left was done using the same model in two ten-minute poses. Look at the figure on the right, and at the sketch. The bench is dark, and in my sketch I drew what I actually saw—maybe as many as six value distinctions. Compare the sketch with the same section in my painting, where, if you squint, you can see that I've merged many of the separate values into one or two. Does the sketch look flat? Compare it with the painting, where the torso and lower legs seem to come forward while the arm and upper leg disappear. Losing some parts and making others clear and focused gives dimension and depth to a picture. Squinting is our best guide: Simplify, blur, and lose what's hard to see.

CENTURY MODELS 3.26.93
Winsor & Newton 90-lb. cold-pressed paper, 14 x 17½" (35.6 x 44.5 cm)

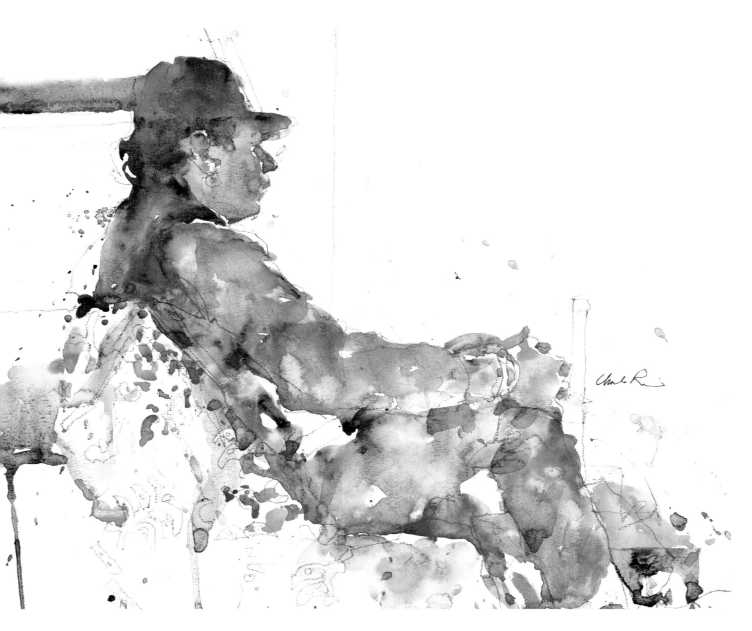

BASEBALL CAP
Old Dutch Aquarel 140-lb. cold-pressed paper,
15½ x 19½" (39.4 x 49.5 cm)

One of the best ways to see less is to work with backlighting. In this painting, look first at the carefully drawn silhouette shapes in the face and follow down to the hands, then look at the carefully drawn light shapes describing the eye, cheek, nose, ear, and collar. The rest of the figure is done rather casually, with smudges and blurs. Backlighting gives you the exquisite little details, the delicate play of light illuminating the carefully realized shapes that bring a blur of colors and shapes into focus. Every painting needs the blurred, the undefined, the suggested, the reality and the mystery, all in one.

ADDING FIGURES TO LANDSCAPES

Some painters add figures to their landscapes, while others add landscapes to their figures. Personally, I'm not secure with landscapes, especially broad vistas. I need something in the foreground, so I guess I fall into the "adding landscapes to figures" category. I need the figure as a foundation, so I always start a painting with a figure or whatever other foreground element I'm using. It's a security thing; if I do a decent job in the foreground, I feel encouraged and have something definite, something on which to base the mystery of painting trees.

I'd much rather do all of my pictures on the spot than in the studio; it's so much easier, because you react to your subject naturally and don't plan too much or have time to worry about mistakes. Unfortunately, this isn't always possible, but when I work in the studio from references, I set myself time limits and never repaint. I'd rather start over again. To me, painting is about finding a careful carelessness and a calculated, controlled spontaneity.

In the paintings on these two pages the sun rises behind the fisherman, his line swirling, spilling flecks of light. I did the first of them in the studio working from a fuzzy slide, some watercolor sketches, and fresh memories of a wonderful salmon fishing trip with my brother.

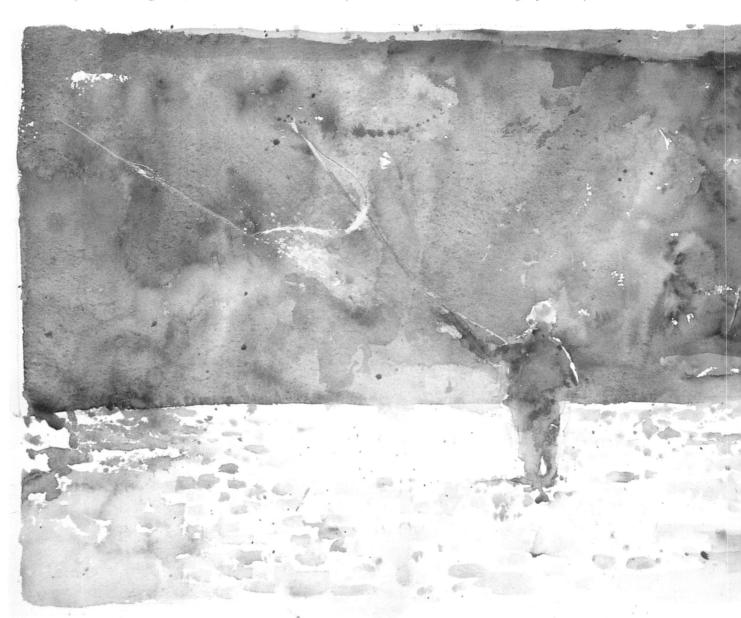

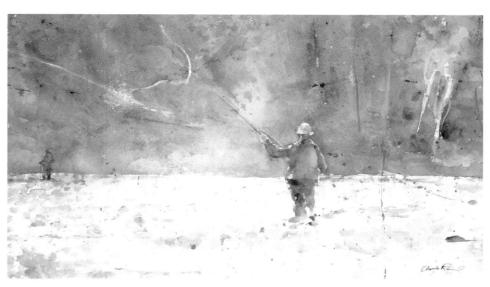

CACHE POOL
*Fabriano rough paper, 22 x 30" (55.9 x 76.2 cm),
collection of Donn Byrne, Sr.*

This painting is based on the earlier one at left, but this time I made the background warmer and the foreground figure larger. I wasn't particularly conscious of these changes; I was taking more time, wanting to make a good painting. My goal was to give this work a sense of immediacy—as if I'd painted it on the spot.

CASTING
*Fabriano rough paper, 16 x 22" (40.6 x 55.9 cm),
collection of Dr. and Mrs. Gordon Reid*

The figure must be right, so I finished him first. Keeping the background in mind, I made sure the values in my silhouette were dark enough, with edges that wouldn't be abrupt when I moved into the surroundings. I then changed the tilt of my board from its usual 45-degree angle to a 180-degree angle to paint the background wet in wet. I used ultramarine blue, phthalo blue, raw umber, and alizarin crimson, adding some cadmium yellow in the trees above and to the right of the figure. In a case like this, you mainly want a simple, almost single background value that is lighter than the figure. To create the effect of light reflecting off the fishing line, I scratched into the wet paint and used some opaque white. Sometimes to grab the eye in a composition like this, I add a dash of red, even if it isn't really there.

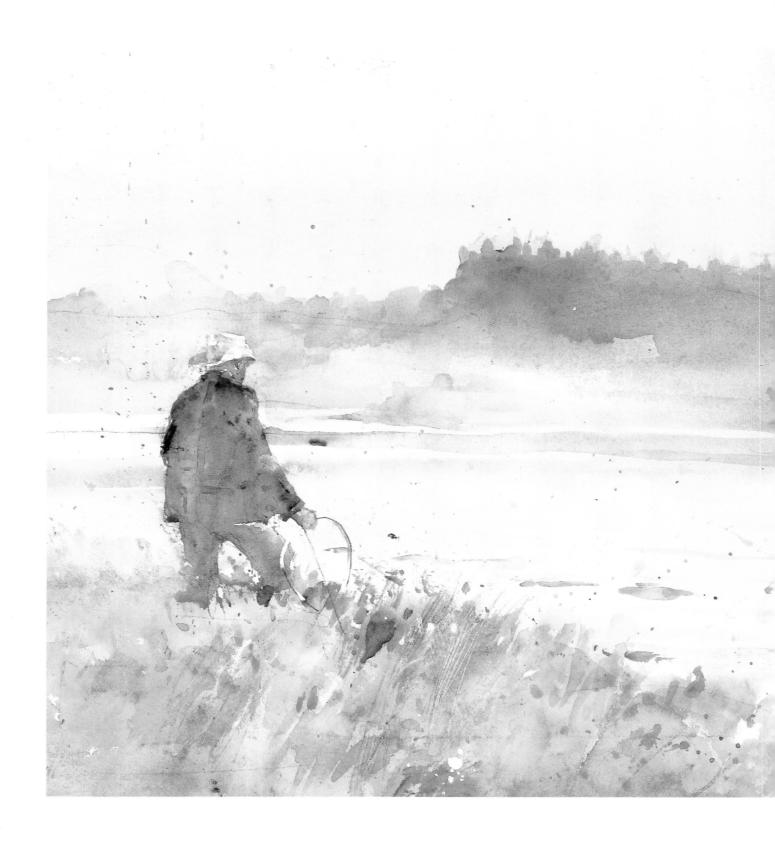

SUMMER POOL
Fabriano rough paper, 22 x 30" (55.9 x 76.2 cm),
collection of Donn Byrne, Sr.

Usually I base my compositions on the placement
of colors and values rather than on the placement
of people and objects. When I do think about where
to locate these more concrete elements, I shy
away from arcane theoretical approaches to
composition and shamelessly fall back on the
"Magic Triangle," something I read about long ago.
Exquisite in its simplicity, it essentially works this
way: Imagine a triangle that has three "legs" of
unequal length and encompasses most of a given
picture. At each point of your triangle, place
picture elements that will catch the eye—a dark
value, an intense color, a person or object of
interest. The three elements should vary in size,
shape, color, and/or value, and one should be a bit
dominant, but without overpowering the other two.
Look at my fishing compositions and see how I
used the "Magic Triangle."

PAINTING
Fabriano cold-pressed paper,
22 x 14 (55.9 x 35.6 cm)

INDEX

Arms, 26, 27, 29, 60, 63, 69, 75

Background
 integrating figure and, 120–23
 landscape, 128, 139
Backlighting, 137
Back view, 28–30
Black model, 104–5
Brushes, 39
Brushwork, 7, 40–43, 57, 116

Clothed figure, 114–19
Color
 changes, 60–61
 palette, 37
 spots of, 52–53
 temperature, 36
 warm/cool, 36, 63, 70, 75
 See also Skin color
Color mixing
 on palette, 38, 52, 57, 60–61, 109
 on paper, 44–45, 114
Composition, 126–42
 essentials, 136–37
 figure in landscapes, 138–42
 flattening picture plane, 128–35
 "Magic Triangle" in, 141
 with sketch class figures, 126–27
 with spots of color, 52–53
Contour drawing, 7, 10–21, 100
 basic guidelines for, 10–11
 boundaries/edges in, 16
 dot-to-dot approach in, 12–13
 feature placement, 19–21
 with pen and wash, 18
 starting, 14–15
 three-dimensional form, 16–17

Dark complexions, 46–49
Dot-to-dot approach, in contour drawing, 12–13
Drawing. See Contour drawing; Gesture drawing

Easels, 39
Edges
 blurred, 65
 crossing boundaries, 109, 127
 defining, 111
 hard, 64, 65, 69
 losing and finding, 16, 111
 of projecting forms, 73
 ragged, 104
 of shadow shapes, 83
Extended palette, 37
Eyes
 contour drawing of, 10–11
 distance between, 87, 89, 91
 and feature placement, 21

rendering, 90–91
socket, 80, 82, 89, 91
and structural form, 86, 87

Facial features, 86–95
 in contour drawing, 10–13, 86
 with lights and darks, 76–82
 mouths, 20, 94–95
 noses, 92–93
 placement of, 19–21, 23, 88–89
 and structural forms, 86–87
 See also Eyes
Figure painting, 98–123
 background in, 68, 120–23
 black model, 104–5
 clothed figure, 114–19
 foreshortening in, 70, 71, 72, 106
 gesture, 50–51
 nude, 106–13
 pose, 98–103, 106
 silhouettes, 56–59
 See also Color; Composition; Head;
 Shadows; Value
Flesh color. See Skin color
Foreshortening, 70, 71, 72, 106
Front view, 22–27
Full palette, 37

Gesture drawing
 back view, 28–30
 front view, 22–27
 kneeling figure, 31–33
Gesture painting, 50–51

Hale, Nathan Cabot, 76
Hawthorne on Painting, 52
Head
 and facial structure, 86–87
 figure in relation to, 29, 100, 101
 length of, 106
 See also Facial features
Hood, Dorothy, 7
Hue, 36

Jones, Frank, 7

Kneeling figure, 31–33

Landscapes, figures in, 138–42
Legs, 26–27, 29–30, 71, 75
Light
 direction of, 16, 66, 67
 shapes, 47, 76–83
Limited palette, 37

"Magic Triangle," 141
Mapping lines, 16
Materials, 36–39
Model

black, 104–5
pose, 20, 98–103, 106
Mouths, 20, 94–95

Negative shapes, 114, 127, 130, 134
Noses, 92–93
Nude figure, 106–13

Paints, 36
Palettes, 37
 color mixing on, 38
 full/extended/limited, 37
Papers, 36, 99
Pencils, 99, 108
Pens, 10, 18
Perspective, 128
Picture plane, flattening, 128–35
Planes, 66, 67, 76
Pose
 capturing, 98–103
 normalizing, 20, 98
 reclining, 71, 106
Positive shapes, 114
Projecting forms, 70–75
Proportions, 70, 71

Reclining figure, 71, 106

Shadows
 cast, 68–69, 74
 form, 68
 monochrome, 58–59
 shapes, 47, 62–67, 76, 77, 78–83
 simplifying, 113
Shoulder line, 20, 21, 23, 29, 65
Silhouette figures
 with monochrome shadows, 58–59
 simple, 56–57
Skin color, 99, 106, 114
 basic, 47, 48, 60
 of black model, 104
 dark complexions, 45, 46–49
 mixing, 44–45
Spots of color, 52–53

Three-dimensional form, in contour drawing,
 16–17
Transparent colors, 36

Value, 36, 132, 136
 changes, 60–61
 darker, 46, 68, 69
 and projecting forms, 70, 73, 74, 75
 sketch, 121
Vertical alignment, 98

Wash
 first, 109, 110, 114, 115
 and pen, in contour drawing, 18

Edited by Marian Appellof
Designed by Jay Anning
Graphic Production by Ellen Greene